IMAGES
of America

OCEAN CITY
VOLUME II

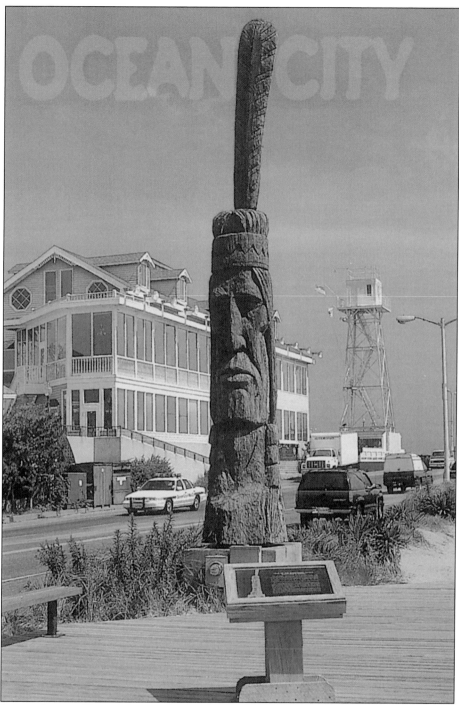

A CARVED INDIAN HEAD. This recent photo shows the sculpted Assateague Indian Monument as it rises over the water, eclipsing the inlet and facing Assateague Island. Artist Peter Toth, now age 50, arrived in Ocean City in 1976 and carved this gift for the resort in testimony to the Native American Indians. By 1986, he had sculpted 58 such figures—one in at least every state in the union and in Ontario. (Courtesy of Roland Bynaker of Trade Winds.)

IMAGES
of America

OCEAN CITY
VOLUME II

Nan DeVincent-Hayes, Ph.D. and John E. Jacob

ARCADIA
PUBLISHING

Published by Arcadia Publishing
Charleston, South Carolina

Printed in the United States of America

Library of Congress Catalog Card Number: 99-62865

For all general information contact Arcadia Publishing at:
Telephone 843-853-2070
Fax 843-853-0044
E-mail sales@arcadiapublishing.com
For customer service and orders:
Toll-Free 1-888-313-2665

Visit us on the Internet at www.arcadiapublishing.com

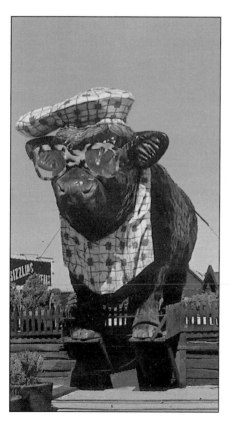

CAPTAIN BOB'S AND THE BULL. Captain Bob's is owned by Bob and Kayrell Wilkerson and operated by their son Tim, his fiance, and his sister. The restaurant is famous for its steak and seafood, as well as its entertainment for which Tim has designed a concert venue that features national bands, acts, and events such as a "pajama party." The restaurant started out as a summer produce stand in the 1960s that went wild in sales. Within a few summers, the stand turned into an inside-eating spot and then a full-fledged restaurant. Equally renown is the Wisconsin-made fiberglass bull (named "Mr. Ocean City") as shown in this 1975 image. The figure stands about 18 feet high and weighs 2,000 pounds. The bull has served as a dissertation topic for doctoral students, a meeting spot for visitors, and an item to gaze upon and take pictures of for tourists. Laughs Tim, "It's even supposed to be an object of worship for groups in saffron robes praying to it in the early hours of dawn." Bandits have tried stealing the bull's 4-foot-long and 2-foot-high sunglasses. The bull's standard attire is a beret, scarf, and the beach shades, but, on special occasions, he can be seen dressed as Santa, a ghost (called "Boo Bull"), or the Easter Bunny. The bull has become an icon in the resort. (Courtesy of Pulling/HPS.)

CONTENTS

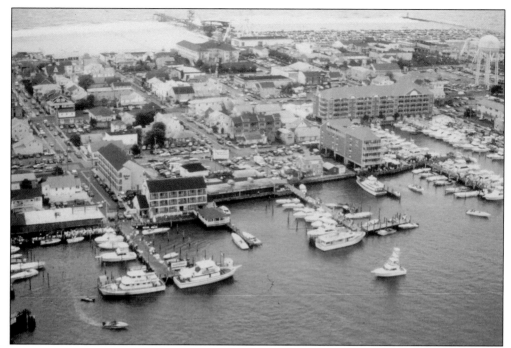

AN AERIAL VIEW OF OCEAN CITY. This aerial view gives a good impression of what the harbor side of the resort looks like. The ocean is in the background. This appears to be the lower end of the resort since no high rises are cast against the horizon. Notice that all side streets off Coastal Highway either lead only to the bay or to the ocean. The yachts and boats in the harbor generally moor there for the summer, since no vessels are allowed to harbor on the ocean side. (Courtesy of Landy Tyler and Ocean City Public Relations.)

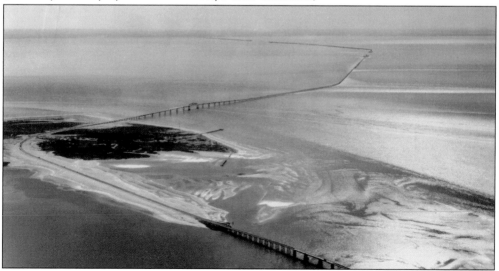

A MAN-MADE WONDER. Ocean City opened up to the world when the Chesapeake Bay Bridge-Tunnel was built. Connecting the Eastern Shore of Virginia to the mainland of Virginia, the construction spans 17.6 miles at the mouth of the Chesapeake Bay; it also features 12.2 miles of trestled roadways, 4 man-made islands, and 2 tunnels. Part of the excitement of this roadway is driving underwater through the tunnels. (Courtesy of David Snead.)

HISTORICAL OVERVIEW
1947 to Present

This volume looks at Ocean City's growth from the late 1940s to the present. It is an interesting history simply because the small resort—only 5 square miles in size—took everyone by surprise when it nudged its way into history by becoming one of the most sought after places to vacation, one of the most popular retreats on the seaboard, and one of the most crowded loafing spots anywhere.

Some of the city's growth is attributed to the raising of the Verrazzano Bridge from Virginia into Maryland in 1963–64, as well as the opening of the William Preston Lane Jr. Memorial Bridge (a.k.a. the "Chesapeake Bay Bridge") in 1952 at a cost of $41 million. The second bridge was constructed in 1973 at a cost of $129 million. At the opposite side, the Bay Bridge-Tunnel, coupling the Eastern Shore of Virginia with the Virginia mainland, was built for $200 million. Part of the tunnel runs underwater. With these new connections to the peninsula, getting to and from Ocean City became easier, bringing in hordes of vacationers and ushering in the rapid growth period of the resort.

The decade of the 1950s saw the laying of new streets and the widening of old ones, the fashioning of an airport, and the beginning of deep-sea fishing. The late 1960s brought population and real estate surges, land annexations, improved and new infrastructures, one of the first trailer parks, destruction from another storm, and the creation of such organizations as the Life Saving Service and the Beach Patrol. The 1970s witnessed Ocean City's largest growth expansion in its history, with Condo Row headlining the news. It also marked the inception of the Ocean City Life Saving Museum. By the end of the decade, a period of real estate glut occurred, resulting in foreclosures. The 1980s brought about clamming, luxury townhouses, and re-zoning policies for a small town that now laid claim to being one of the densest resorts in the country. In 1988, the replenishment program began for the 10 miles of beach. The 1990s saw better planning and greater maintenance of infrastructures.

There's no end in sight for Ocean City's growth as more and more families discover this delightful gem that welcomes casualness and informality, offers relaxation and amusement, and encourages devotion and warmth in family relationships. The success of the island's growth depends on its politicians and business people to properly plan, maintain, and forge ahead. So far, the little funland and its people have done a grand job of it, and they're ready to herald the millennium.

ACKNOWLEDGMENTS

Many people have helped us put this second volume together through their tireless research and assistance or through their willingness to take time to provide us with information. Although we can't name every individual, we do want to stress our appreciation to the owners of establishments who graciously talked with us and gave us much needed material and facts or helped us track down those people who could supply the knowledge we needed.

We especially thank Bo Bennett, who has unselfishly volunteered her time to perform research and photographic projects. She always has willingly checked and double-checked facts for us, tracked down unavailable information, and given of her time to go out and perform shoots. We thank you.

We also thank Donna Abbott and Norma Dobrowlski of the Ocean City Public Relations Department for their endless help and cooperation; Landy Tyler for her photography; Aaron White, Mac Simpson, and Patty Burton, for their insights on condo growth; Nite Lite's John Woyt for his patience in explaining entertainment in the resort; Tim Wilkerson for his information on his restaurant, Captain Bob's, and the bull; Jamie Caine for detailing the Caine developments; Betsy Fantleroy of the Harrison Group for all her information; Lauren Connor Taylor for her input on early motels, including her Santa Maria; and Mary Corddry and Sue Hurley for their insights.

We are grateful for the photo permissions of Moore, Warfield and Glick Realtors; Vaughn Lynch of Shoreline Properties; and the Anderson Group. We also appreciate the photo permissions of Kenna Brigham and Carol Hussey; Art Baltrotsky and Patricia Moore of Baja; Betsy Fauntleroy of the Harrison Group; Pam Harrington and Sunny Day Guides for their images and for the use of the Trimper's aerial shot; Color by Aladdin Photo for the Alamo and other images; Roland Bynaker of Trade Winds; R.C. Pulling of Pulling/HPS; Charlie Smith of Fager's Island; Bill Gibbs of the Dough Roller; Gregory Von Rigler of Sky Tours; the *Eastern Shore Times*; William Campion of Delmarva Postcards; photographer Andrew Serrel; Diane Fauntleroy of Princess Royale; David Snead of Virginia; and Tom Heiderman of the Hobbit.

We give thanks and acknowledgement to the following postcard publishers/photographers: Ogden and Associate, Vista Graphics, Mannah Photography, MWM Co., Brooks Photography, and Harry P. Cann & Bros. Co.

We also wish to extend our gratitude to the estate of the late Fred Brueckmann and to offer our condolences to his family on his recent death. His postcards have been an unending resource for us.

INTRODUCTION

If popular Ocean City is too small to hold all its tourists, then it's too big to accommodate all in one volume; hence, this is the second volume on the resort and it covers the era of 1947 to the present. We are grateful to all the photographers who have kindly given us permission to use their images. Those photos not credited are the work or collection of the authors.

In this volume, you'll ride buses and boardwalk trains; sunbathe on widened beaches; smell popcorn popping, funnel cakes frying, ham smoking, and fries sizzling; see towering Ferris wheels spin, upside-down coasters roll, and the still-operational Trimper's merry-go-round circle. You'll hear the swish of elevators as they surge upward to the tops of high-rise buildings, taste the salt in the ocean spray as tides lash against jetties, and feel shoulders touching shoulders on the crowded "boards." And when the sun rises over its mirrored reflection in the water, you'll gasp at its glory, and when that same ball of fire sets over the bay, you'll sigh at its magnificence.

Here, in this volume, you'll read about how the resort's growth exploded and endless hotels and condos were built at high prices, and then how the city became so saturated with lodging facilities that every high rise, except two, went under. Banks foreclosed. Those people with money were able to buy auctioned property for a third of the going price. The Carousel Hotel, built by indicted Bobby Baker of the Senate, was one of the first to be hit hard and has faced problems since it inception. It was bought, sold, then bought again, and again. Then in the mid-1990s, the Carousel faced more problems when electrical work was not up to code and condo owners were not getting paid. The current owner went bankrupt, and, on May 27, 1999, the Carousel was bought for about $7.5 million, much less than its value.

Also in this book, you'll see how the town has sprouted into a mature resort with aging problems and, yet, has not only come into its own but has become even bigger and better. There are more things to do in this little town than all of the Eastern Shore of Maryland, from new amusement rides, to high-tech games, sport tournaments, kite flying, rollerblading, and, of course, swimming and sunbathing, among a host of other dazzling recreational activities. Golfing is "big-time" in and around the resort, as well as on the Eastern Shore as a whole. Some of the choicest golf courses and the most challenging mini-golf courses can be found here.

Events have also increased in number (festivals, parades, contests, performances) and each of these has attracted more and more people, so much so that Ocean City, once only a summer resort, has fast become a year-round retreat. Both Sunfest and Winterfest have become nationally known, pulling in crowds from all over the country. One could easily take hours strolling through the city's museums, especially the old Life Saving Station, which is not only an enjoyable venture but also a fine learning experience. A lot of time and work has gone into making this museum a top-notch cultural center.

Dining, dancing, and nightlife have become an exciting staple of the town. Some of the country's best and most unique restaurants can be found here, as well as specialty foods unequaled elsewhere. Themed dancing venues abound, and one is never at a loss for a place to

have fun morning, noon, or night, or for a place to get a certain food or have the finest meal or a just quick bite to eat in swim trunks or bathing suit.

Boardwalk improvements have become the talk of the town, with the renovation of the 2.6-mile stretch (from the inlet going north) costing $3.5 million. This trademark of the resort is being torn up and re-done, concrete is being replaced, and the boardwalk is being widened in other places so that half the "boards" will serve pedestrians and the other half will allow the boardwalk train to travel uninhibited by strollers and without posing a danger to those more interested in window shopping and testing food at booths and stalls than listening to the clanging of the train's bells.

There's never a dull moment in the town, and people remain friendly and almost child-like in their wonder no matter how crowded the boardwalk is, how much traffic fills Coastal Highway, or how difficult lodging is to get at season's peak. Ocean City is a place to visit and then return to again and again because every year the resort offers something innovative and exciting.

In this volume, Ocean City is at its height of maturity, at its moment of greatest growth (all for you to take in and enjoy as this resort welcomes its annual 8 million visitors). Be one of them by leafing through the pages of this book and sharing in this incomparable oceanside story.

We'll enjoy your company.

<div align="right">

Nan DeVincent-Hayes, Ph.D.
John E. Jacob

</div>

One

AERIAL PHOTOGRAPHS

Aerial photography is a wonderful thing. It freezes, for all to see, the greedy grasp of developers, the tracery of roads, the erection or destruction of buildings, and the spread of parking lots. Applied to Ocean City, aerial photography has recorded the changes in the earth's surface, the filling in of marshlands, the slow accretion and depletion of sands, the building of new high-rise apartments, and the dredging of canals.

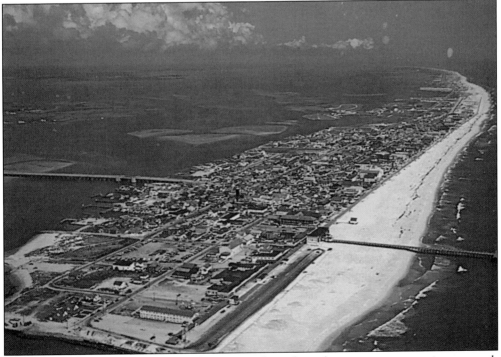

AN AERIAL VIEW OF OCEAN CITY. This picture shows how the resort narrows as it goes north and how it curves to the left; it also shows some of the former islands and peninsulas of the Sinepuxent Bay.

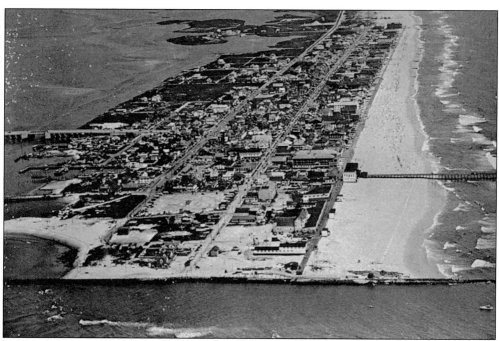

OCEAN CITY, 1946. The first half of this double card shows the new bridge, the inlet, the boardwalk that ended at Seventeenth Street, the beach highway, the parts of St. Louis Avenue that have not yet been connected, and the emptiness of the land on the bay side.

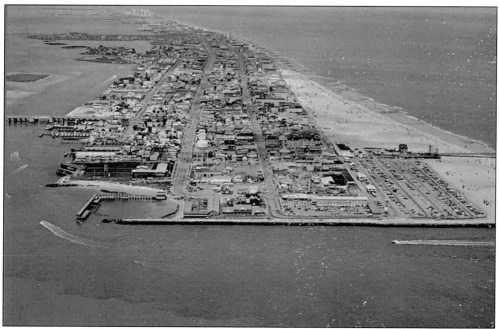

OCEAN CITY, 1976. The most notable changes in this view from the previous one are the parking lot on the beach, the completion of St. Louis Avenue, the development of land on the bay side, the new high rises barely visible at the extreme top of the picture, and the movement of Trimper's amusements on the beach.

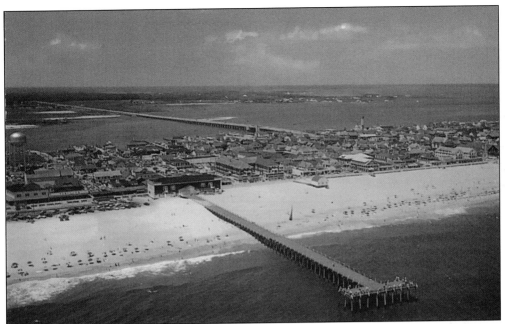

AN AERIAL VIEW OF THE CENTRAL SECTION. This picture was taken before 1946. The parking lot at the south end is only two lanes wide, there are no amusements built on the beach, and the bandstand is still to the north of the pier.

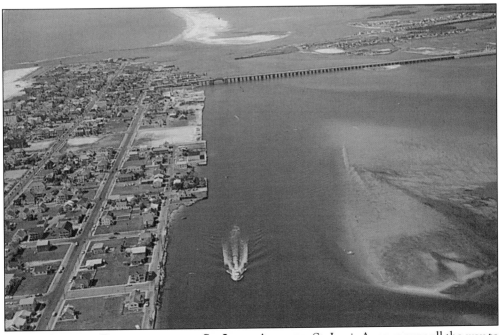

A VIEW SHOWING PHILADELPHIA AND ST. LOUIS AVENUES. St. Louis Avenue runs all the way to Fourteenth Street, but the side streets adjoining it are still nearly empty.

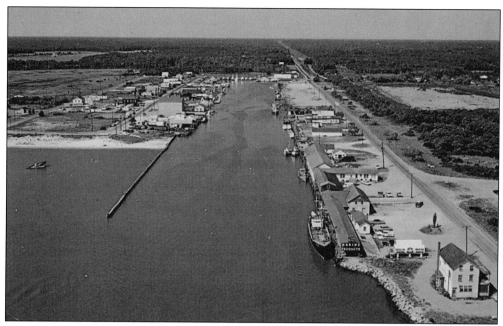

THE HARBOR IN WEST OCEAN CITY. This shows the roads on each side of the harbor, the new road inland, and the many boats tied up at various places in the harbor.

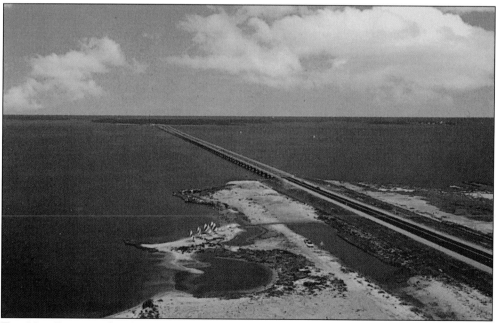

THE NEW BRIDGE. This shows the new bridge to North Ocean City, which comes in at Sixty-second Street, just after it was finished.

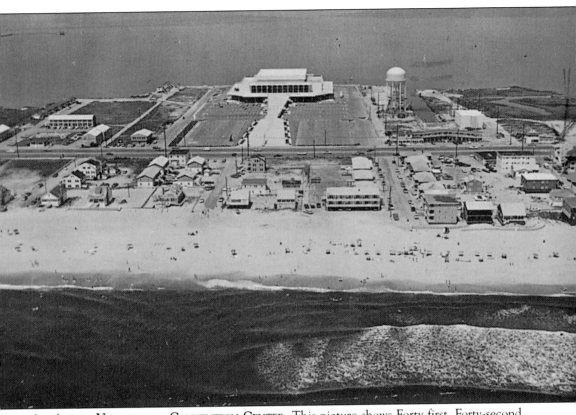

AN AERIAL VIEW OF THE CONVENTION CENTER. This picture shows Forty-first, Forty-second, and Forty-third Streets and also faintly shows how narrow Ocean City is at some points.

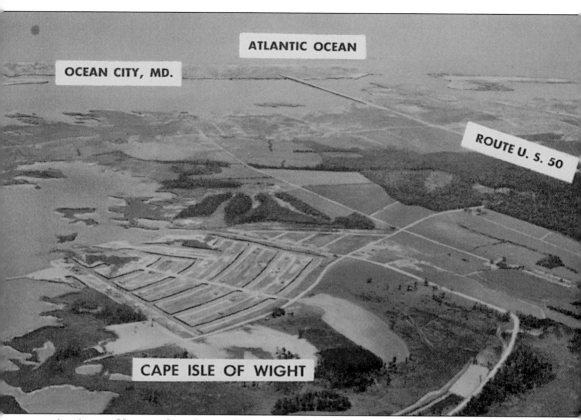

ATLANTIC OCEAN

OCEAN CITY, MD.

ROUTE U. S. 50

CAPE ISLE OF WIGHT

An Aerial View of Cape Isle of Wight. The labels make it easy to locate where you are and also clearly show how much vacant land there was near Ocean City in the late 1940s. (Courtesy of Sperry Printing; collection of David Dipsky.)

Two

HIGH RISES:
Hotels, Motels, and Condos

It wasn't until the mid-1940s, after the war, that motels made their first appearance. The Seascape was the first motel, followed by Miami Court, and then the Santa Maria, which since has undergone major renovations. All three of these lodging facilities are still in existence today. By the 1950s and 1960s, motels had overshadowed cottages and boardinghouses. Because of the ability of having cars drive directly to the area of the rooms, motels often were referred to as "motor courts." Their existence raises the age-old question of whether the chicken or the egg came first, as, here, the question is whether the emergence of restaurants prompted the arrival of motels, or whether the construction of motels prompted the surge in restaurants since no motel served food. More important to tourists than the heavy meals were the creature comforts in such conveniences as air conditioning, television, and baths, which motels offered but cottages and boardinghouses did not. This chapter covers the era of the motels since their hey-day occurred in the 1950s and 1960s, although they are still going strong today. Also featured are hotels and high rises, and the problems they have faced.

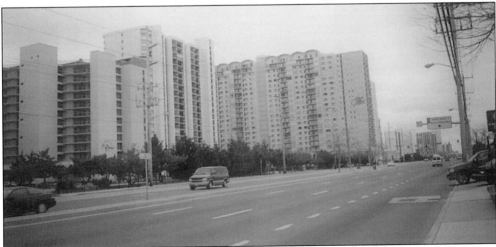

CONDO ROW. This image gives an overall view of what North Ocean City looks like. Some refer to this section as "Concrete Canyon" because of all the cement used in building the high rises, roads, and parking garages. There is no boardwalk at this end. The buildings in the foreground, from left to right, include the Rainbow, the Irene, and the Capri. Farther down the block are the Golden Sands, Marigot, Sheraton, Atlantis, the Quay, High Point North, and High Point South.

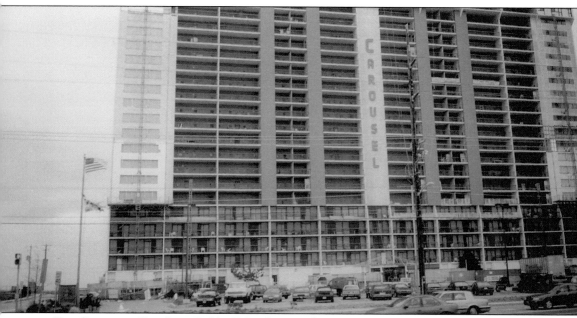

THE CAROUSEL. Developer Bobby Baker borrowed money in 1961 to build the Carousel hotel/ condos, which presented him with endless problems from losing his partners to losing the partially built motel in the March 1962 storm. Still, a grand opening took place in July 1962. With the advent of the Carousel came Baker's friends: Vice President Lyndon Johnson and his wife, numerous senators, representatives, and other congressional staffers. Baker resigned his senate position when he came under investigation for fraud and income tax evasion; he was indicted in January 1966 on nine counts. While Baker was in Lewisburg Federal Prison between January 1971 and June 1972, developer Max Berg purchased the 76-unit Carousel for $2.5 million and added 155 rooms and 189 condo units, as well as an indoor swimming pool, ice skating rink, exhibit and meeting rooms, and a convention center, along with a 535-space, five-story garage. Berg then sold his interest to move on to other projects. The years 1972–74 witnessed an over-construction of high rises; developers went into debt, and ongoing construction was halted. The Carousel was caught in this dilemma and went to foreclosure with an indebtedness of over $16 million. It was auctioned at a loss for $5.1 million, but troubles for the hotel weren't over. Recently, it's come under attack for shoddy work and other defects, placing the owner, Dr. Siamak Hamzavi, in the position of losing ownership if he fails to borrow the $3.5 million necessary to bring the building up to code, to pay utility companies, and to pay his condo owners. Hamzavi has filed for bankruptcy, and the Carousel was auctioned in May 1999.

WAI-KI-LEA. This 1962 photo shows a two-story building that houses cottages and apartments at Frankford Avenue in Fenwick, Maryland. Owned and operated by Mr. and Mrs. Alexis von Bretzel, the structure looks lonely amid the only four other buildings. Notice that Peppers lodging sits in the background, and that the beach is set off away from the buildings. (Courtesy of the late Fred Brueckmann; Tingle.)

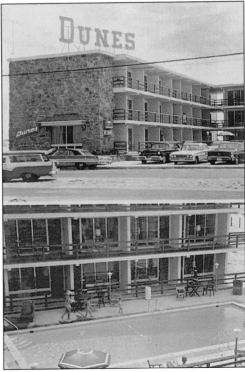

THE DUNES MOTEL. This photo, taken c. mid- to late 1960s, shows one of the earliest hotels built in the 1960s. Located on the corner of Twenty-seventh Street and the beach, the Dunes Motel was purchased by Thelma and Milton Connor in 1966. These innkeepers, who knew the hospitality business inside and out, ran the business for years before they planned for the construction of a Victorian-styled hotel. The name Connor is associated with the hotel-motel business, and it seems their legacy lives on as their offspring and relatives continue to operate lodging facilities. (Courtesy of the *Eastern Shore Times*.)

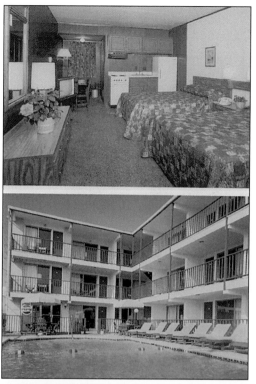

SHANGRI LA. This 8400 Coastal Highway hotel is a seasonal operation and was built in 1969 by Philip and Doris Harrington. It opened July Fourth of the same year to a hullabaloo of fireworks and excitement. Twenty-nine motel efficiencies are available with balconies overlooking the pool. The owners still employ many of the workers who first started with them. (Courtesy of Sunny Day Guides and owner Pam Harrington.)

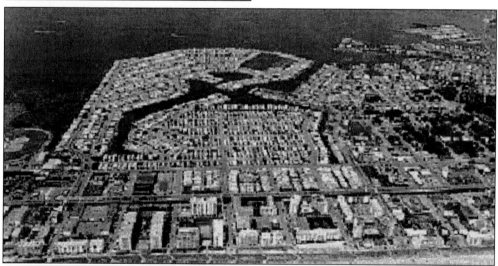

MONTEGO BAY. This housing development was created by the industrious and visionary James B. Caine and his Montego Bay Development Corporation in 1968. Holding 1,000 homes and housing 4,000-plus residents, the development extends from 130th Street to 134th Street on the west side of the island. With over 128 creditors demanding a total of $25 million in payment, Mr. Caine filed for bankruptcy in 1977. Jamie Caine clarifies that "Jim Caine developed 90th Street to the Delaware line in the late 1960s, [including] Caine Keys I, II, Caine Woods, Montego Bay, and Caine Harbor Mile, and everything on the Ocean Block from 90th Street to the state line." (Courtesy of Paul Smith of Shore Aerial Photographers and V. Lynch of Shoreline Properties.)

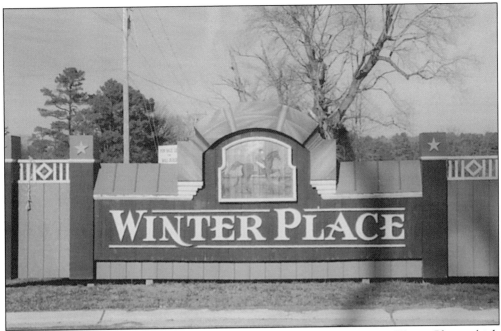

WINTER PLACE FARM. Opulent living can be seen here in James B. Caine's Winter Place, which held a near stadium-sized riding arena, carpeted stalls stabling 40 horses, crystal chandeliers, and a carriagehouse with 80 surreys, runabouts, sleighs, milk wagons, and the like (all of which were bonafide and priceless antiques). Thus, somewhere around June 1976, creditors took Caine's Winter Place antique carriages and auctioned them for around $323,000 to help satisfy Caine's debt. This is a 1999 photo.

A SMALL PART OF WINTER PLACE FARM. In March 1978, Caine's land and buildings were auctioned to the tune of $400,000 to satisfy a debt. This was followed by his loss of Lighthouse Sound for $1.8 million. Never fulfilled was Caine's hope for developing a $10-million bayside recreational complex, a Holiday Inn, the Caine Harbor Mile property earmarked for 73 acres, and the 700-acre Lighthouse Sound Country Club housing two 18-hole golf courses, a tennis compound with 30 courts, a marina with a 1,000-boat storage facility, indoor-outdoor swimming pools, and other planned projects.

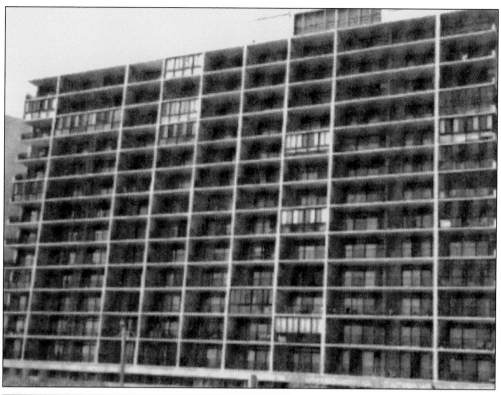

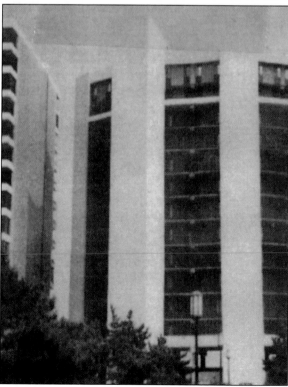

HIGH POINT. Constructed in 1970 by John Whaley, this structure built of informal lines and with bright colors is considered the resort's first high-rise condo at 15 stories, which was more than twice the height of most buildings on the entire peninsula of the Eastern Shore of Maryland. Soon after the erection of this building, Whaley fashioned High Point North (above), but prior to this companion building, High Point had towered all alone at the undeveloped northern part of the town, serving as a beacon for other builders to develop that end of the resort. Rapid construction did take place, so much so fast that it resulted in many foreclosures after the resort became saturated with more lodging units than it was with vacationers. Of all the condos, only the Century and the Golden Sands condos were not auctioned. (Courtesy of Moore, Warfield and Glick Realtors.)

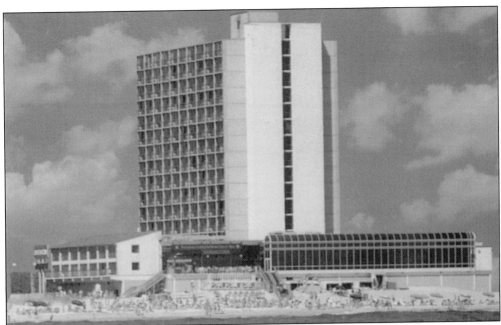

SHERATON FOUNTAINBLEAU. While High Point represented the inciting factor in the fast growth of North Ocean City, the Fountainbleau stood as the first luxury high-rise motel in 1970. Today, this 40,000-square-foot high rise has been renovated and redecorated. Each unit has its own balcony, and the facility offers endless luxuries, such as steam and eucalyptus rooms, spas, workout rooms, tanning beds, Jacuzzis, pools, and a hair and nail salon. Its nightclub, Horizon, offers live entertainment. Adjacent to this tall building at 10100 Coastal Highway is the oceanfront Marigot Beach Condominium Suites. (Courtesy of Eastern Aerial Photography.)

ENGLISH TOWERS. Around 1971, during the housing boom that saw nearly 1,300 condos built in Ocean City, James English built these towers on 100th Street on open sand that once was the home of surfers and beachgoers. English topped off this construction with a neighbor building he called Century I that was 28 stories tall. Soon after, English began building two more condos. (Courtesy of Moore, Warfield and Glick Realtors.)

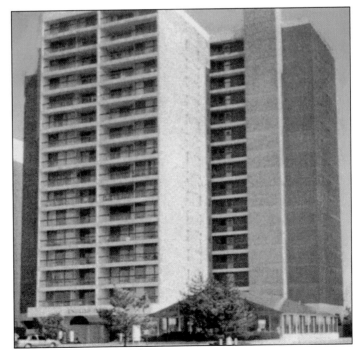

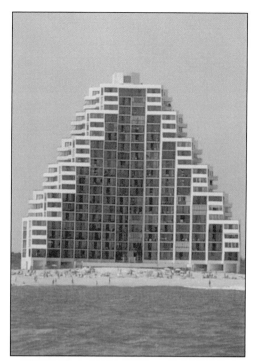

THE PYRAMID. Built c. 1972 by John Whaley, units in the Pyramid began selling in 1974 for $50,000 to $60,000. Then the crash came. Loyola Bank foreclosed, and the building was auctioned. Unit prices dropped to the $32,000 to $40,000 range, but today, they're worth four to five times that. This is the only concrete-poured building to the fifteenth floor, and it is considered to be the safest, quietest, and most desirable lodgings in spite of all the problems faced during construction, from exorbitant inflation rates to worker sabotage. Built on over 225 pilings with transverse slabs, nearly each wall is 6 inches thick and load-bearing. Designed by New York City socialite-architect Bob Morgan, the Pyramid has been featured in many national magazines. Its style, intended to eliminate the casting of afternoon shadows on the beach and to provide oceanfront views from every residence except the end units, has won it several architectural awards. (Courtesy of William Campion of Delmarva Post Cards.)

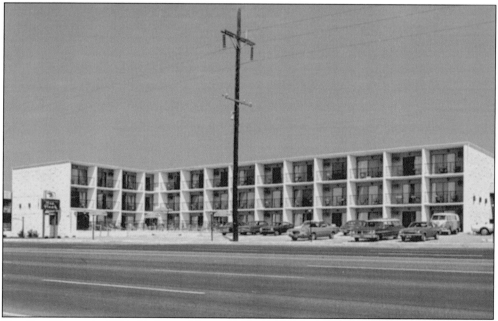

THE SEA HAWK. In 1972, Philip and Doris Harrington constructed this lodging facility, which is currently owned by Doris and her offspring since her husband passed away. Although her daughter, Patricia Murrell, died, her siblings, Philip Harrington Jr., Pam Harrington, and Susan Sturgis, still operate the facility with the assistance of staff, some of whom are original employees. In addition to efficiencies, 60 units were added to the fourth floor in 1986 to create a bigger motel. The Sea Hawk remains a seasonal business at 124th Street and Coastal Highway. (Courtesy of Pam Harrington and Mannah Photography.)

THE FOUNTAINHEAD. This 18-story structure on 100th Street cost about $4.5 million for Max Berg, then age 45, to erect. Berg was a self-made man who had lost his family to the Nazis, while he, himself, had to crawl out of a mass grave. He came to America penniless and without family to build an empire of his own. By the early 1970s, he had become the sole main investor in the development of condominiums in Ocean City. Originally, two-bedroom condo units sold for around $50,000; today those same units cost from $150,000 to 175,000. (Courtesy of Moore, Warfield and Glick Realtors.)

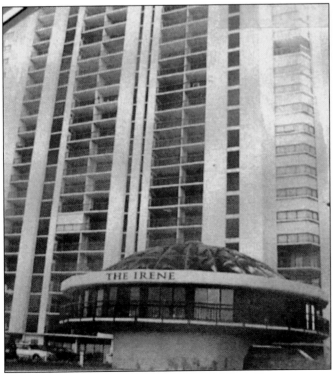

THE IRENE. Before Berg even completed his Fountainhead project, he was already into the construction of this 21-story high rise in 1974, which proved quite a challenge since building tall structures on sand at sea level was discouraged. Named for his wife, the Irene cost $5.5 million to build, resulting in the largest construction mortgage in the county of Worcester. Berg claimed that he had sold 70 percent of the condo units before he had even begun construction of the building. The units were costly for the 1970s at a sale price between $45,000 and $62,500. (Courtesy of Moore, Warfield and Glick Realtors.)

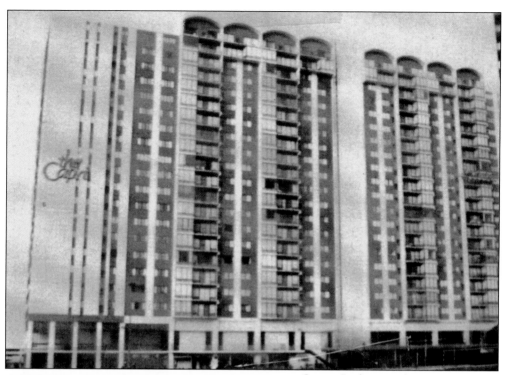

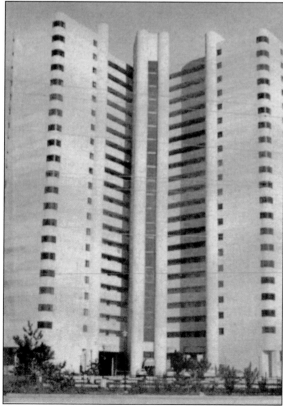

CAPRI. Built around 1973, this high rise has had three owners; the current ones are Mr. and Mrs. Richard Thomas Jr. Because of the over-development of high rises in North Ocean City in the 1970s, a glut of lodging resulted, and with that came defaults. Mary Corddry, in her book *City on the Sand*, states that this 21-story beachfront condo "was by far the biggest foreclosure sale in Eastern Shore history." A lending firm purchased it for $5.85 million, and this began a domino effect. There were over 3,000 unsold condos by the mid-1970s. Bargain deals were made on empty units. (Courtesy of Moore, Warfield and Glick Realtors.)

ATLANTIS. A few months later, this 21-story high rise was next in line for auction (the second biggest foreclosure in Eastern Shore history). Built by a New Jersey firm, it was sold to a Philadelphia bank for $7.7 million (Photo by Andrew Serrel; courtesy of V. Lynch of Shoreline Properties.)

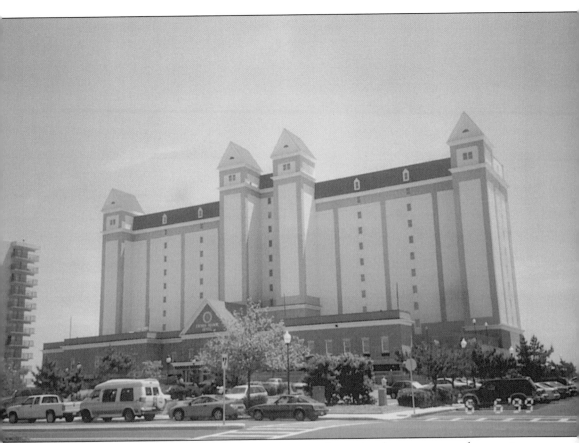

DUNES MANOR HOTEL. By 1979–80, the purchasing of vacation homes was on the upswing again. Ocean City had over $33 million in building permits beginning in 1980. One of those projects in 1987 was this hotel. While planning for its construction at 2800 Baltimore Avenue, Milton Conner died, leaving his then-74-year-old wife, Thelma, to execute the plans. Never one to shy from monumental tasks, she completed the construction. Now at the age of 86, she has lived to see it flourish. It stands in testimony as one of the high rises built with quality, and overseen almost single-handedly. Its 160 majestic rooms and 10 suites are Victorian styled with balconies that face the ocean. For the past 12 years, Thelma Conner herself had appeared in the lobby to serve free tea to guests in the afternoons. Weekends witness live sing-song piano music. And when the guests desire a breather, they step out onto the wide veranda and lean on the balcony or sit on wicker chairs and soak in the cool breeze. (Photo courtesy of the Dunes Manor Hotel.)

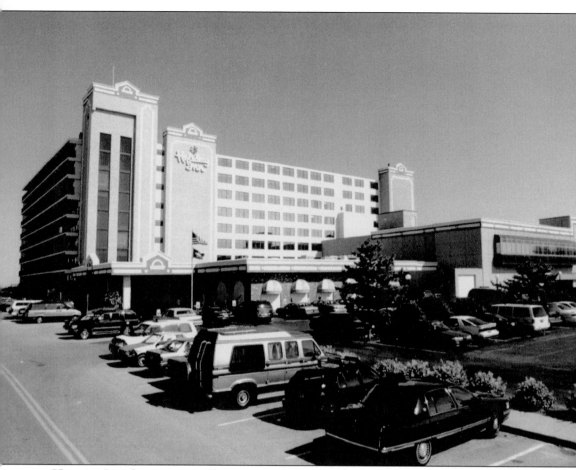

HOLIDAY INN OCEANFRONT. This structure represents the business acumen of John and Hale Harrison, who have built a lodging empire that includes Quality Inn Oceanfront at Fifty-fourth Street, Quality Inn Boardwalk at Seventeenth Street, the Plim Plaza and the Harrison Hall Hotel (both on the boardwalk), Ramada Limited at Thirty-second Street, Best Western Flagship at Twenty-sixth Street, and Holiday Inn Oceanfront at Sixty-second Street. The Harrison family got involved in the hospitality business when John and Hale's parents, George and Lois Carmean, built Harrison Hall in 1951. When George died in 1961, his sons, ages 14 and 12, stepped in to help their mother. By the time the boys were in high school, they owned a nine-unit apartment house, the Barbizon. Hale claims their mother "gave them enough rope to hang themselves but always stood ready to make sure [they] didn't die." After college, the brothers purchased and modernized the Plim Plaza in 1979, the Quality Inn Oceanfront in 1973, the Best Western Oceanfront in 1977 (formerly the Diplomat), in addition to converting a couple of buildings to restaurants. In 1981, they constructed a new the Holiday Inn Oceanfront, one of the first structures built to be a year-round facility. It was remodeled in 1997 to offer such conveniences as bath telephones, dishwashers, 25-inch remote-control color TVs, VCRs, pools, Jacuzzis, saunas, tanning beds, a game room, a playground, and tennis courts. (Courtesy of The Harrison Group.)

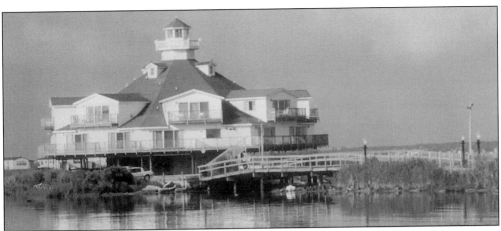

THE LIGHTHOUSE CLUB MOTEL. The final hours of New Year's Eve 1988 witnessed the opening of a three-story octagonal structure, one of the most exclusive and resplendent hotels in Ocean City. Owned by John Fager, the Lighthouse Club Motel has 23 suites decorated by Lawrence Peabody of New York City overlooking the bay. They feature elegant white marble, triple-sheeted linen for the queen-sized four-posted beds, three phones, a sectional sofa, personalized lighting, fireplaces, circular winding stairs and balconies, Jacuzzis, and stocked refrigerators, among other luxuries. A member of the exclusive "Great Inns of America," the Lighthouse Club Motel's rates are nearly $300 per night for some rooms during peak season. (Courtesy of Charlie Smith of Fagers Island Restaurant.)

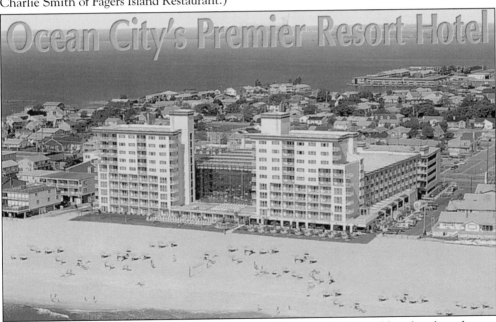

PRINCESS ROYALE. This April 1997 photo brings to life a grand and regal hotel and conference center built in 1991 and located at 9100 Coastal Highway. The owner went all out in constructing the facility, which is the only 310 two-room "all suite" hotel in town and also offers condominiums, an enclosed four-story glassed atrium, a convenience store, a jewelry shop, hot tubs, a recreation room, and a full service salon. A variety of entertainment is also offered, such as a comedy club during the summer season. (Courtesy of Diane Fauntleroy and Vista Graphics.)

29

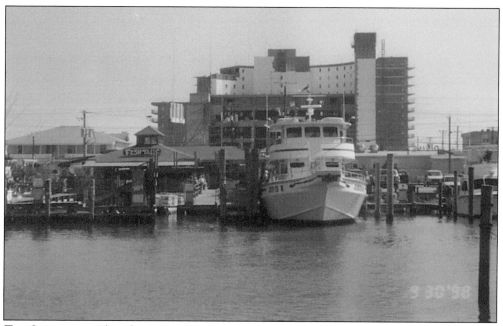

THE STOWAWAY. This photo was shot from the bay side toward the ocean, showing the front side of the building under construction. The high rise had already been in existence in the resort before the owners decided to erect a new structure. Because of zoning, financial, and construction problems, completion of the building is taking much longer than expected, but as this photograph indicates, it appears to be solidly forged with concrete and will offer a fine view of both the ocean and the bay. (See p. 64 for a view of the original motel at this location.)

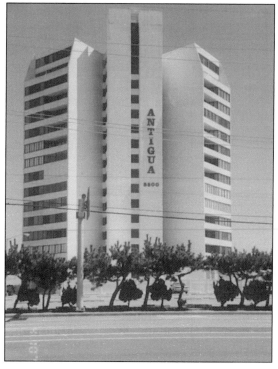

ANTIQUA. This photo of the front of the building at Eighty-fifth and Eighty-sixth Streets is representative of some of the uniquely constructed condos in North Ocean City. Built in 1975, the condo's back is round in form in order to give each individually owned unit the ability to view the ocean, but the front's circularity is broken up by a tall rectangular structure. Additionally, the structure was so shaped to defer wind effects, causing the wind to funnel up through the front of the building like a chimney. Similarly shaped buildings exist only in Japan, Mexico, and Antiqua. (Photo by Andrew Serrel; courtesy of V. Lynch of Shoreline Properties.)

Three

THE INLET

TO FIFTEENTH STREET

This chapter covers the entire downtown Ocean City area, showing what the area looks like today and at various times since the 1940s. Every decade in Ocean City has made a tremendous difference in the city's landscape; if you stayed away for 30 years, you would be lost today. The number of concrete block first floors in this area is attributable to local ties with a block plant that used cement and local sand.

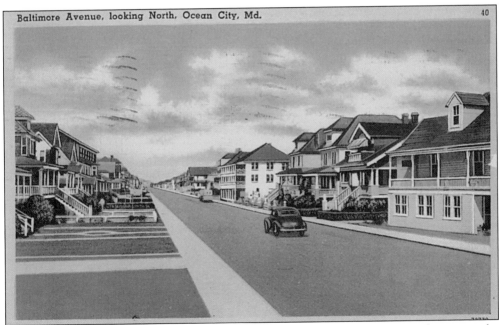

Baltimore Avenue, looking North, Ocean City, Md. 40

BALTIMORE AVENUE, LOOKING NORTH. This view from the early 1950s shows the area at the junction of Baltimore Avenue and North Division Street. North Division and Baltimore do not meet at right angles, and the building in the right foreground, while facing Baltimore Avenue, was parallel to North Division. The view was taken coming off the bridge. (Courtesy of Edward Stores and the late Fred W. Brueckmann.)

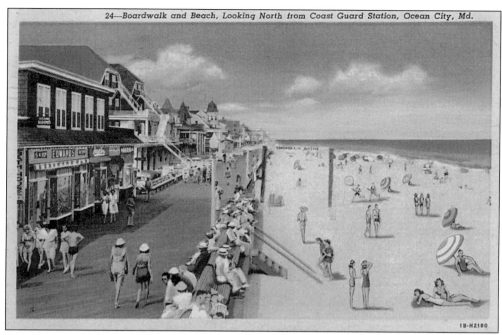

THE BOARDWALK, LOOKING NORTH FROM THE COAST GUARD STATION. Edwards Stores is on the left with the Roosevelt Hotel behind it in this *c*. 1950s image. The Plim cupola is recognizable in the background. (Courtesy of Harry P. Cann & Bros. Co.)

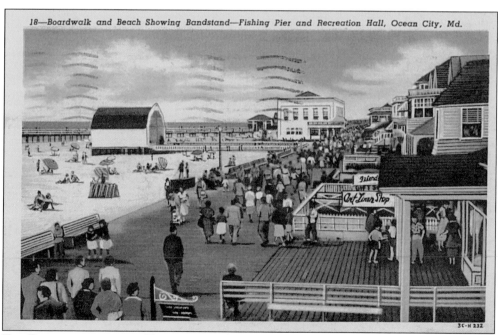

THE BOARDWALK AND THE BANDSTAND. This picture, with the bandstand visible on the left, is from the late 1950s. The Art Linen Shop owned by Paul Hishmeh was stocked with really fine linens and was a fixture in Ocean City during this time. Hishmeh also owned a shop in Salisbury, Maryland. (Courtesy of Harry P. Cann & Bros. Co.)

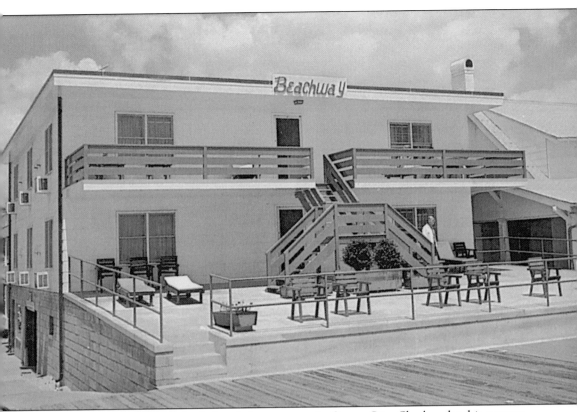

THE BEACHWAY. This was Maude Law's first venture in Ocean City. She bought this cottage, completely rebuilt it, and then discovered the pilings were rotten. She was forced to jack it up and put a new block foundation and basement car park under it. Law also air-conditioned the cottage and ended up with this attractive building at the corner of Second Street. (Courtesy of the late Fred W. Brueckmann.)

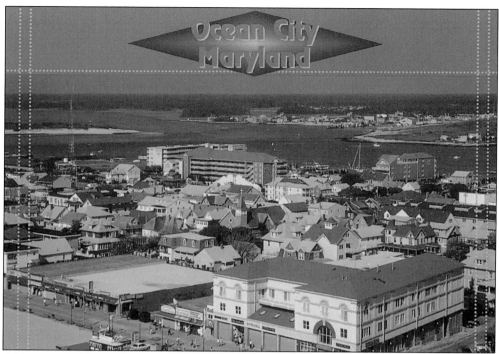

A PANORAMIC VIEW. This postcard shows the inlet on the left and West Ocean City in the far background. Edward's Store, housed in a new modern building, is in the foreground, but still in the same location as in the earlier view. Notice the new motels near the inlet and the marina catering to sport fishermen. (Courtesy of Roland Bynaker of Trade Winds.)

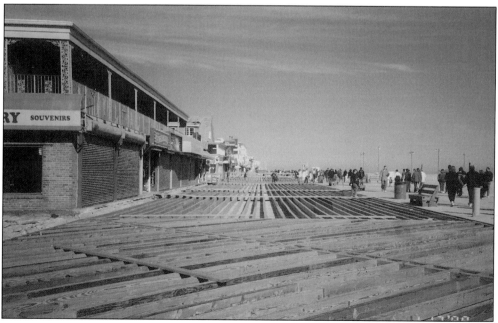

BOARDWALK REBUILDING. The boardwalk has been made much wider with concrete on the ocean side, wood on the shop side, and plenty of room for the boardwalk trains.

THE OCEANIC MOTEL. This motel, built for the sport fishermen and their families, is located on South Philadelphia Avenue. (Courtesy of Jack Rottier.)

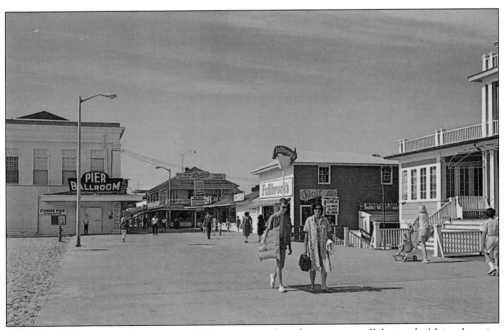

THE PIER BALLROOM. This is a *c.* 1960s picture, but dances are still being held in the pier ballroom. Dolles Salt Water Taffy is also still in the same place. The two-story building next to the Atlantic Hotel was operated by Harry Fullbrook, who was a city councilman in Salisbury in the 1960s.

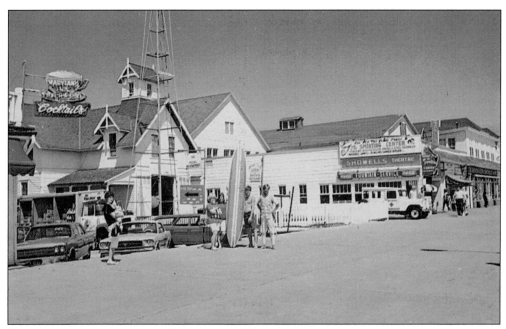

THE BOARDWALK AT CAROLINE STREET. In 1978, the Coast Guard moved to a new location and turned their Ocean City station over to the city, which used it as the headquarters for the Beach Patrol. The city was later sued by heirs of Stephen Tabor, who had given a deed to the Coast Guard with a revocable provision (they won and got possession of the lot). This picture dates from 1980 while the Beach Patrol was still using the structure. The cocktail sign in this view is on the Maryland Inn.

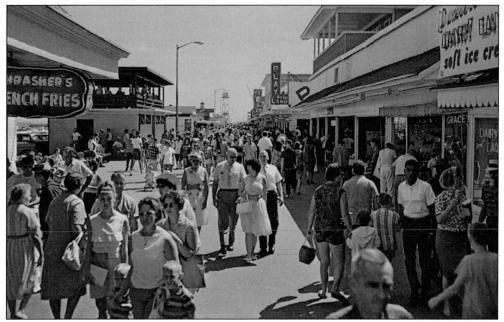

SUNDAY STROLLING IN THE 1970s. Though this image shows them during the 1970s, Thrasher's french fries, Dumser's ice cream, and Playland are still some of the most favored treats and spots in Ocean City today.

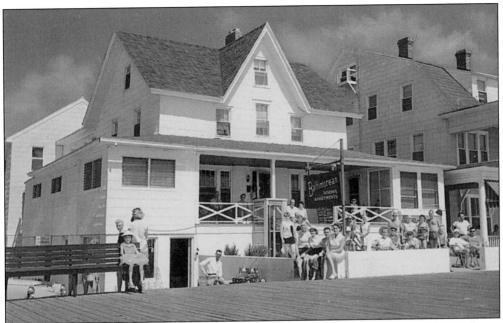

THE BALTIMOREAN. This house is located at First Street and the boardwalk. The card says that Mr. and Mrs. George Shuster, the owners of the house, were members of the Ocean City Golf & Yacht Club. The printed statement was probably necessary for their guests to play golf. (Courtesy of the late Fred W. Brueckmann.)

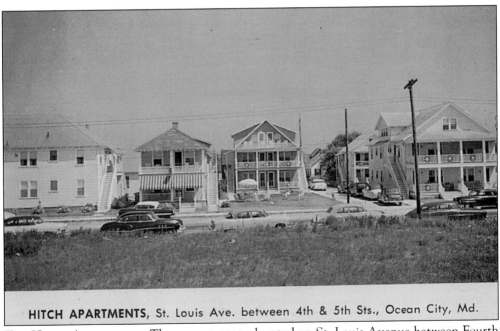

HITCH APARTMENTS, St. Louis Ave. between 4th & 5th Sts., Ocean City, Md.

THE HITCH APARTMENTS. These apartments, located on St. Louis Avenue between Fourth and Fifth Streets, belonged to Mr. and Mrs. Raymond Hitch of Fruitland, Maryland. The structures are still at this location but are now linked together. (Courtesy of the late Fred W. Brueckmann.)

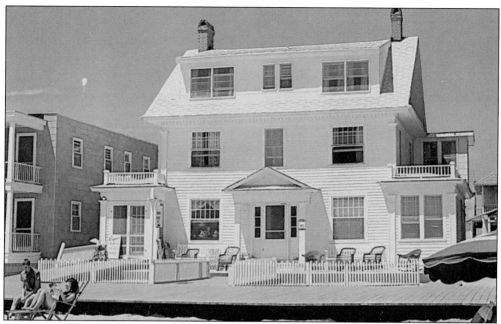

EUGENIA'S GUEST HOUSE. In addition to running her guest house, Mrs. Eugenia Palmisano also sold gifts and antiques and arranged fishing parties. Located at 511 Boardwalk, it is now the Kite Loft. (Collection of David Dipsky.)

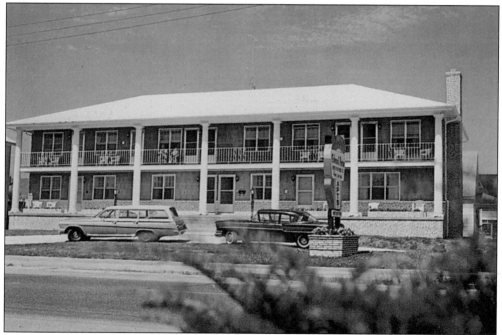

THE COLONIAL ARMS APARTMENTS. Found on Philadelphia Avenue at Seventh Street, this apartment house has acquired a model white horse and a real carriage and parked them at the front door. When asked what was the significance of the horse and carriage, the reply came that the owner thought the pieces were in keeping with the building's name. (Courtesy of the late Fred W. Brueckmann.)

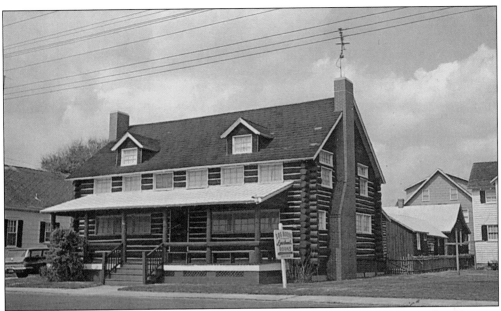

The Log House. This apartment building really is a log house, quite an unexpected structure to be found on Philadelphia Avenue in Ocean City. (Courtesy of the late Fred W. Brueckmann.)

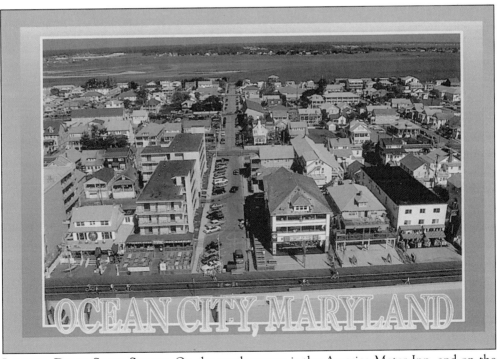

Looking Down Sixth Street. On the south corner is the America Motor Inn, and on the north is the Sea and Sand Apartments. The Bon Jour Café is located inside the Motor Inn, and next to it is the Kite Loft. Heading north on the boardwalk, we come across the Columbus Villa and the Boardwalk Discount and Electric Sun. On the corner of Baltimore Avenue is the home of former state's attorney Jack Sanford. (Courtesy of Roland Bynaker of Trade Winds.)

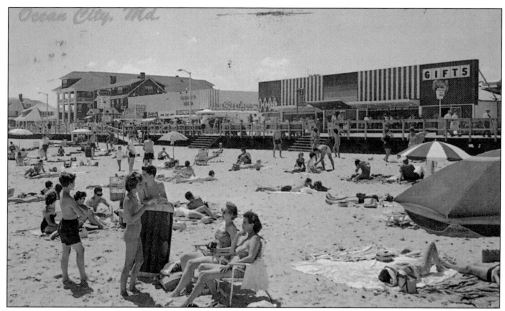

NINTH STREET SHOPPING CENTER. This was the first real shopping center on the boardwalk outside of the amusement area. Hess Apparel, then a highly regarded Eastern Shore clothing chain, had a shop here. The Ember's Restaurant was also located here. The auction gallery held sales every night, and the Candy Kitchen offered its sweet wares. A gift shop and an Alaska stand completed the inventory. This beach scene shows a lot of potential customers. (Courtesy of *Mardelva News*.)

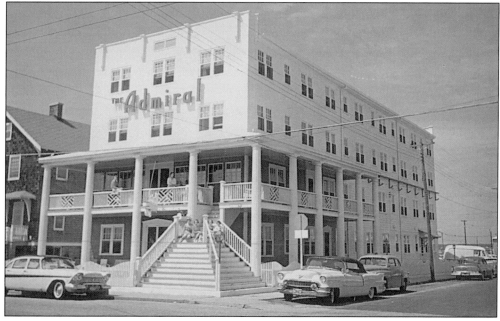

THE ADMIRAL HOTEL. Built in 1939, this hotel is located at Ninth Street and Baltimore Avenue and the big steps are still in place. Mr. and Mrs. William Esham bought the Admiral Hotel in 1959 and now own most of the neighborhood; they have painted much of it the same color—yellow. (Courtesy of the late Fred W. Brueckmann.)

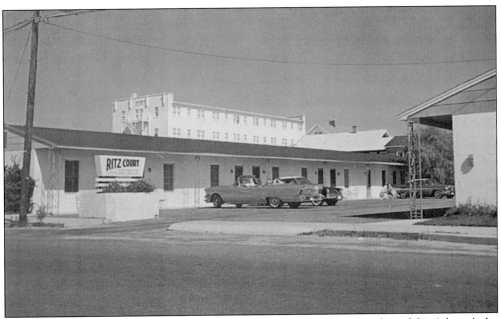

THE RITZ COURT. The Ritz belonged to the Eshams prior to their ownership of the Admiral; the Ritz was likely the foundation of their empire. (Courtesy of the late Fred W. Brueckmann.)

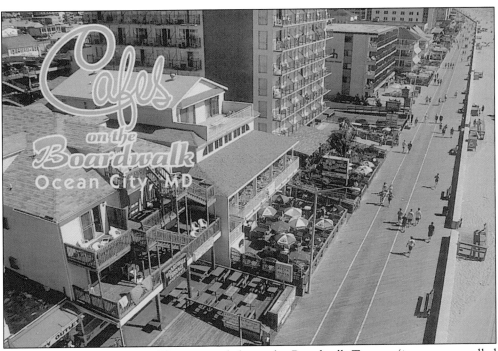

CAFÉS ON THE BOARDWALK. This postcard shows the Boardwalk Terrace (it was once called Journey's End) on the left. The Bull on the Beach, the Gulf Stream Pub, the Brass Balls Saloon, and the Bad Ass Café are all located on this block. (Courtesy of Roland Bynaker of Trade Winds.)

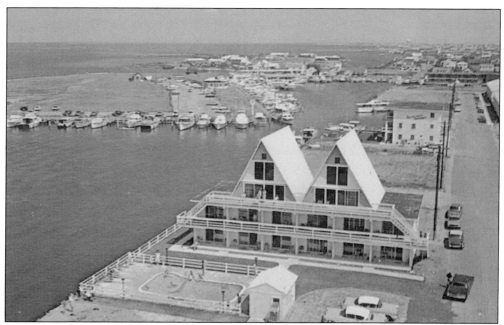

THE CHALET APARTMENTS. These apartments are located at Eleventh Street on the bay and are the chief building block of another kingdom. The Chalet has expanded across St. Louis Avenue and southward on the same side with more motel rooms. The Yacht Club Island is visible across the bay. (Collection of David Dipsky.)

THE OCEAN TERRACE APARTMENTS. The Candeloro family now owns all three buildings pictured here, having acquired them over the years since 1975. At the corner of Baltimore Avenue and Thirteenth Street, they are now called the Ocean Terrace, but were once the King Charles and the Southernaire.

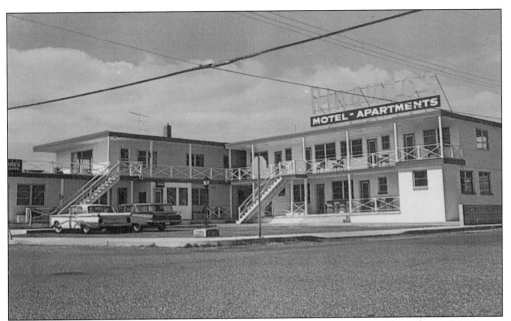

RINAUDO'S MOTEL. This motel is now the Tally Ho, located on Fourteenth Street and St. Louis Avenue. Two apartments have been added to the second floor, and the stairway turns sideways against them. The current assistant manager of the Tally Ho has been associated with the apartments for over ten years and had never heard the building's previous name. (Courtesy of the late Fred W. Brueckmann.)

THE PINK REEF. No longer known as the Pink Reef, this building is now called the Willows. The side lot where people can be seen seated comfortably under umbrellas was sold off. The present owner, John Fink, is a retired gentleman from Baltimore. (Courtesy of the late Fred W. Brueckmann.)

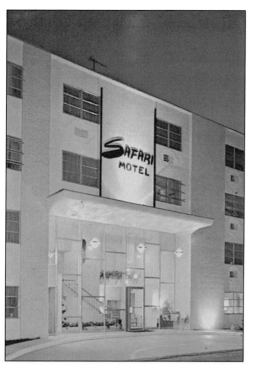

THE SAFARI MOTEL. Located on the boardwalk at Thirteenth Street, the Safari Motel was purchased by the present owners from Mr. and Mrs. Marshall in 1970. Mr. Marshall, who died in 1977, sold the motel to Ted Lizas. Marshall had asked Lizas if he was a family man, and when Lizas told him "yes," Marshall insisted on meeting them, so Lizas scrubbed his family up for inspection and brought them to Ocean City. Satisfied, Marshall then shook hands on a deal (without a written contract) to sell the motel to Lizas for $400,000, and Lizas returned to Washington to secure the financing. Terms of the deal leaked out and so did the fact that there was no written contract involved. Marshall was approached with an offer of $525,000 to sell his motel, which he declined. After settling their deal, Marshall, who ran the Safari Shop, paid Lizas $56,000 for the next two years rent on his shop and turned over the deposits for rent Marshall had already received. (Courtesy of Aladdin Color Inc., Florence, New Jersey.)

THE SAFARI SHOP. The Safari Shop, which Marshall operated until his death in 1977, gave its name to the motel. The shop sold exotic imports from all over the world, with a special emphasis on African goods. The blacktop parking for the Safari was once the site of the Burgandy Inn. Therein lies an interesting tale. Ted Lizas parked his car at the Burgandy when he arrived for the settlement on the Safari. When Lizas returned to get his car, he received a tongue lashing from the female owner of the inn, and she dared him to park there again. Lizas asked her the price of the inn. She told him, unknowingly, that it was more than he could afford, but he extracted from her the price of $60,000. Since he was flush with money from his recent deal with Mr. Marshall, Lizas said, "Sold," and had his attorney draw up the contract. A few years later, Lizas needed parking space for the Safari and had the Burgandy bulldozed.

Four

AMUSEMENTS
AND ATTRACTIONS

Ocean City is not only a sun city but a fun city. This 10-mile stretch of white sand features a plethora of amusements including kayaking, parasailing, surfboarding, powerboating, volleyball, sand sculptures, sunbathing, kite flying,roller coasters, golf, stock cars, museums, and shopping at the Gold Coast Mall, outlet stores, and Shantytown (a unique boutique center on the water).

In addition, special events run year-round, from parades to Fallfest, Springfest, Sunfest, and Winterfest. The city also hosts Arts Atlantica, Winefest, Murder Mystery Dinner Train, Baystar Dinner Theater, Comedy Club, Sweet Adelines, barbershop singers, "Jesus at the Beach," and numerous conventions, water competitions, and tournaments such as the White Marlin Contest. The list of activities is extensive.

When the June-Bugs (graduating seniors from high schools and colleges, or "Junies," as some refer to them) arrive, the area becomes inundated with young people in a short period of time.

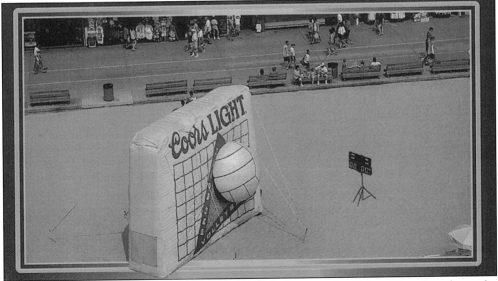

COORS: VOLLEYBALL. This image, taken in 1996 by photographer Roland Bynaker, shows the symbol for the numerous volleyball tournaments hosted by Ocean City. In addition to the Coors World Volleyball Championship, the city also accommodates the Women's World Class Tournament. Other events include contests involving surfing, sailing, racing, classic custom cars, and fishing. (Courtesy of Roland Bynaker of Trade Winds.)

ENJOYING THE BOARDWALK. Without a doubt, strolling the "boards" is a favorite pastime. Bikers, cart and train riders, as well as joggers, walkers, and even "sitters" from all over the world entertain themselves by watching other people, studying the ocean, or visiting stores and endless eating places. In the spring and summer, about 350,000 tourists jam the resort on weekends. A sign on the Harry W. Kelly Memorial Bridge leading out of the resort to Route 50 west reads "3,073 miles to Sacramento." People arrive at the shore by all modes of transportation, from bikes and planes to buses and hitchhiking. Getting across the Chesapeake Bay Bridge and through the Chesapeake Bay Tunnel requires patience, as long lines of traffic form heading for the ocean. During peak season, lodging can run as high as several hundred dollars a night, while off-season offers some rooms for less than $50 a day. Although the bulk of fun things to do are in the summer, Ocean City is fast becoming a year-round resort. Walking the multi-million-dollar, newly refurbished boardwalk is a favorite of not only visitors, but natives as well. The cart in this picture is one of the many modes of boardwalk transportation. (Courtesy of Roland Bynaker of Trade Winds.)

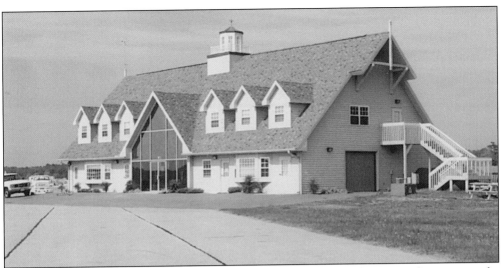

OCEAN CITY AIRPORT. Having opened in 1956, the airport closed its normal operations for resort visitors. Ocean City hopes to re-open the airport once it can handle larger planes and jets, but for now, the city relies on Salisbury's airport, which has recently been dubbed the "Salisbury-Ocean City Airport." As of this writing, Ocean City decision-makers have not determined what to do with the terminal and runway property, but both are open to private charters and such amusements as parachuting and sky tours. (Courtesy of Bo Bennett.)

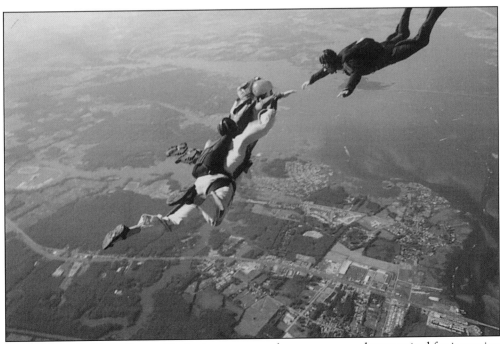

PARACHUTIST'S VIEW. Ocean City's airport may no longer serve as a key terminal for incoming flights carrying tourists, but it does offer other activities and parachuting is one of them. Here, two brave souls jump from a plane that took off from the airport. Both jumpers had undergone parachuting instructions before free-falling. (Courtesy of Bo Bennett.)

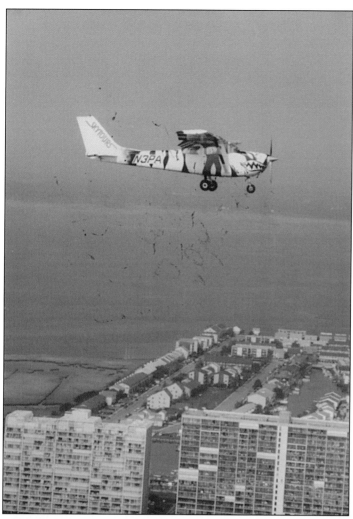

SKY TOURS. This photo depicts Von Rigler's Cessna 172 soaring over the resort at about 1,000 feet with the ocean in the foreground and the bay in the background. For those who enjoy the thrill of viewing areas from thousands of miles high, this is an amusement not to be missed. Tours start at $20 per person and offer sightseeing and historical and ecological information on the barrier island of Ocean City. Owner Gregory R. Von Rigler, who opened the business in 1990, is an FAA-certified pilot of 15 years. Von Rigler reports having had marriage proposals and honeymoons take place on his flights. (Courtesy of Gregory Von Rigler.)

INTERSECTION: ASSATEAGUE ISLAND. This national seashore and state park is a barrier island filled with lush marshlands, beaches, and water. It's a paradise of entertainment for those who like to hike, bike, camp, clam, crab, fish, canoe, kayak, and observe the wild ponies that wander throughout the 37-mile-long island that runs from Maryland through Virginia. A fence separates the two states, which share the job of caring for the native birds and other wildlife and flora. Eco-tours are offered for those who enjoy nature on foot, though visitors may climb in their cars and drive around the island. The wild ponies, especially those on the Virginia side, have been written about and televised in the "Misty" series. Every year, the pony swim and penning event takes place and makes world news. It's interesting to note that while Assateague is spending millions to replenish its beach, the inlet between Ocean City and Assateague needs to be dredged to keep the storm-made waterway open. (Courtesy of Roland Bynaker of Trade Winds.)

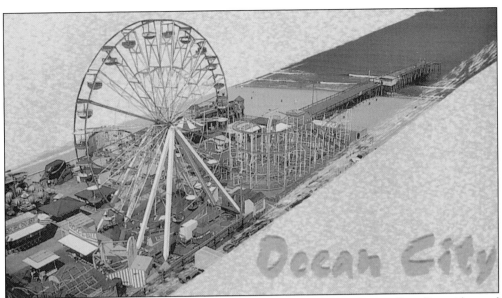

OCEAN CITY AMUSEMENTS. This photo, c. early 1990s, shows Ocean City Pier rides and amusements that can be accessed by entering an alcove next to Thrasher's Fries on the boardwalk. The right side of the photo is at the inlet, although the image doesn't accurately show this. The inlet parking lot begins where the vehicles are parked. The "Giant Ferris Wheel" is over 110 feet high and has 24 gondolas that each hold up to 6 people for a total of 144 riders. Additionally, the pier offers a small roller coaster, the pendulum-like Pirate Ship, and other adventures, as well as an extended pier for anglers. (Courtesy of Roland Bynaker of Trade Winds.)

PASSING THE TIME. Ocean City is favored for skateboarding, though the resort has strict regulations regarding this sport, but it has provided a plot of public land for skaters and their competitions. The park, located at Third Street and St. Louis Avenue, was designated as the Ocean Bowl Skateboard Park in the late 1970s and was renovated in 1998. This new 17,000-square-foot concrete base is a state-of-the-art facility that hosts 10,000 riders nationally. It brings in about $50,000 annually in gross revenue during its five months of operation from July through December. (Courtesy of Roland Bynaker of Trade Winds.)

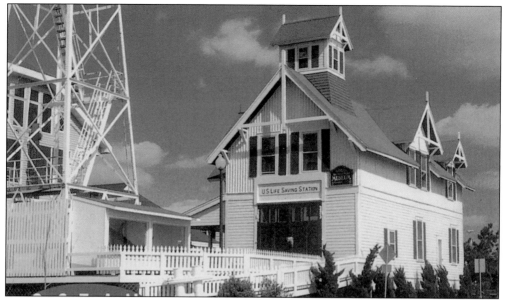

THE OCEAN CITY LIFE SAVING STATION MUSEUM.. Receiving thousands of visitors, this small museum is housed in one of the oldest existing structures in the resort. As the former headquarters for the U.S. Life Saving Service and the Coast Guard, this life saving station moved from Caroline Street to its present place. Now, as a museum, it features exhibits of bathing suits from the 1900s, a saltwater aquarium with marine life, a large shark jaw, a Victorian art shell collection, and samples of sands from different beaches of the world such as Australia, Iceland, Volga, and so on. Models of the resort's various hotels and businesses are also on display, as is "Laughing Sal," the hysterically howling funhouse doll that noted author John Barth wrote about. There's much to see and learn about here. (Courtesy of HPS.)

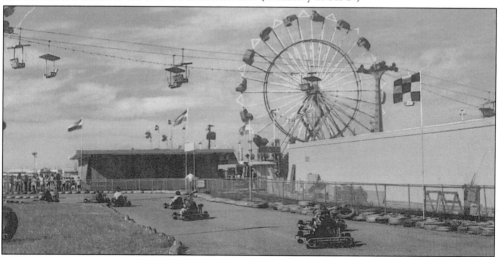

THE ARNOLD PALMER DRIVING RANGE/JOLLY ROGER PARK. This older photo shows a small recreational area that has taken giant growth steps. Touted as the resort's largest amusement park, this enterprise features something for everyone, from all types of golfing, animated gorillas and alligators, a sea creature walk, and a splash mountain to a roller coaster, kiddie rides, water sports, and even famous performers. Owner Mike Jones and his family have been involved in the park for decades. (Courtesy of Tingle.)

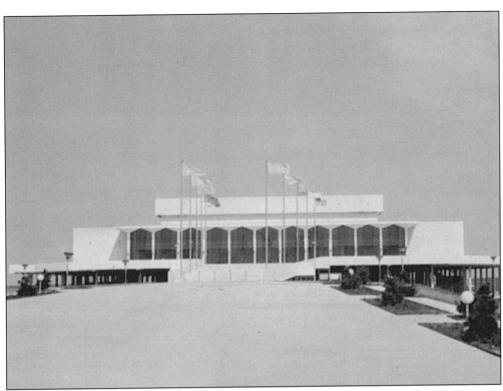

THE CONVENTION CENTER.
The original 1970 convention center is shown above, while the $3.5 million renovated center is at right. Refurbishment was completed in 1997, yielding a facility twice its original size with 80,000 square feet of exhibit halls, meeting rooms, multipurpose areas, banquet space, and a full-service kitchen serving 2,500. The ground floor proffers a new visitors' center, the box office, and administrative offices. The second floor houses a grand ballroom, breakout rooms, and a mezzanine. About $9 million in direct tax revenues to the state is realized by this facility annually. It's not unusual for the convention center to host such large events as the Martin Luther King conference, which attracts well over 67,000 people. (Above courtesy of the late Fred W. Breuckmann; rightcourtesy of Ocean City Public Relations Department.)

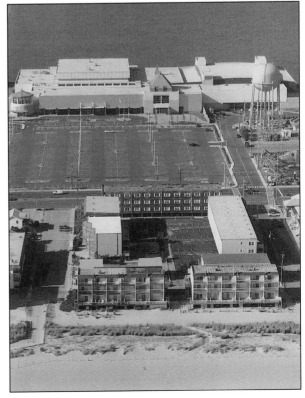

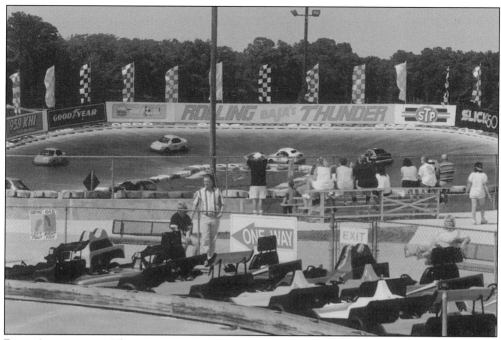

BAJA AMUSEMENTS. This sport is part of Baja's major recreational complex, where there are seven go-kart tracks (some family oriented, others slick and fast), an arcade, a family roller coaster, a 24-foot climbing wall, a carousel, a snack bar, a moonbounce, and mini-golf. In this photo, the Rolling Thunder stock cars are in the background while Gran Prix cars on the family track are in the foreground. (Courtesy of Art Baltrotsky and Baja's Patricia Moore.)

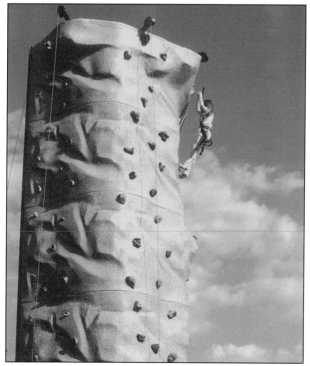

CLIMBING POST. This recent addition to the Baja entertainment center has become a favorite recreational activity. It allows children and adults to develop climbing skills while strengthening muscles and body agility. Children are required to wear two safety lines. Many youngsters have become "king of the mountain" in this recreational exercise. (Courtesy of Art Baltrotsky and Baja's Patricia Moore.)

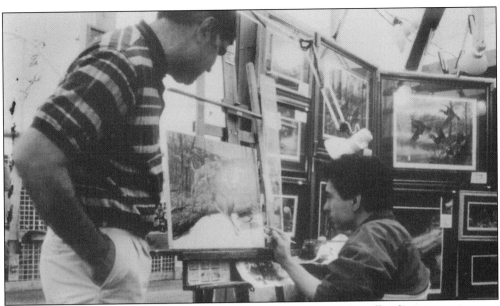

SPRINGFEST. This annual nine-year-old festival occurring every May offers live entertainment, international foods, and art all under big top tents. Thousands flock to the inlet during the four-day festival. In 1998, 150,000 people attended the affair , which featured 400 craft and food vendors. Famous musicians, such as the Kingston Trio and other headliners, took center stage. Equally enchanting is "Art Atlantica," a multi-block festival featuring juried exhibitions of gallery-quality sculptures, jewelry, pottery, paintings, ceramics, and other fine arts. A Chocolatefest and children's arts workshops are part of the event scheduled every year in June. (Courtesy of Ocean City Public Relations Department.)

JULY FOURTH CELEBRATION. Beach parties, sold-out lodging facilities, people underfoot, and packed greens are all signs of this favored annual event that attracts about 340,000 tourists. This is one huge jubilee ringing in appreciation for our country with a powerful Zambelli fireworks shows at the boardwalk and Caroline Street and an orchestra that plays for free at Northside Park and 125th Street. Here, huge crowds enjoy a jamboree with carnival games, booths, food galore, music, and arts and crafts. (Courtesy of Ocean City Public Relations Department.)

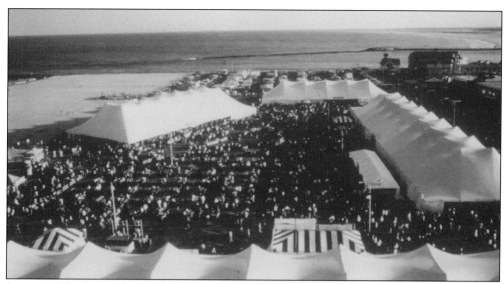

SUNFEST. This September outdoor gala held under tents at the inlet celebrates summer's end and autumn's beginning. Since its inception in 1974, Sunfest has become such a well known and well-attended event that it has been rated among the "Top 100 events in the USA." Contests, a kite festival, famous performers, dozens of different ethnic foods, arts and crafts, pony and hay rides, and other fun things to do fill the Sunfest tents and entertain visitors along with the resort's other numerous activities. (Courtesy of Ocean City Public Relations Department.)

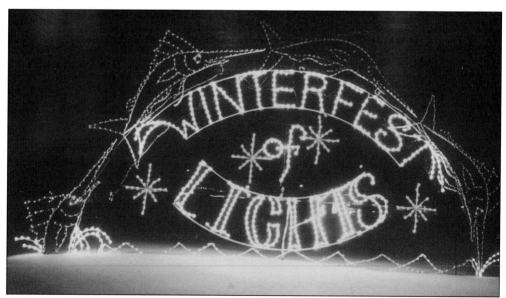

WINTERFEST OF LIGHTS. Since the 1994 yuletide season, Ocean City has been lit up during the holidays with sparkling lights on both the bay and ocean sides. This winter wonderland of 800,000 animated twinklers is displayed over a two-mile section, offering gigantic exhibits of nautical animated figures, such as a deep-sea fishing Santa and dinosaur and penguin villages. At the Northside Park, a ten-minute train ride on the Winterfest Express provides a special view of Santa playing softball, a mountain of skiers, and Jurassic Park. Sponsored by the city, the event attracts spectators from all over. (Courtesy of Ocean City Public Relations Department.)

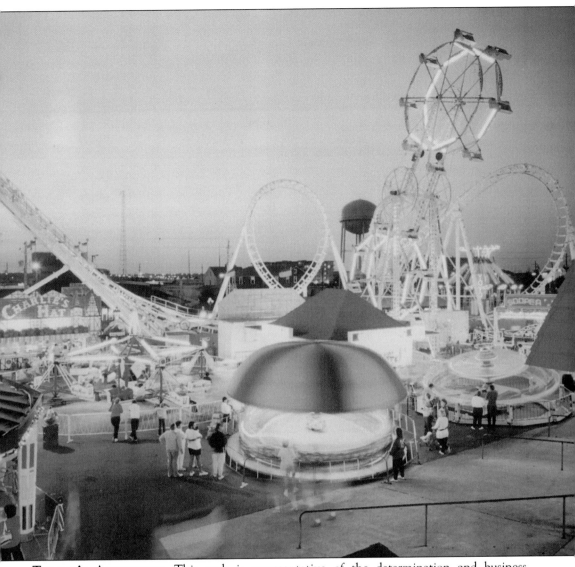

TRIMPER'S AMUSEMENTS. This park is representative of the determination and business acumen of the family of Daniel and Margaret Trimper, who arrived in Ocean City in 1890 and purchased two hotels and the land between South Division and South First Streets in 1893. By 1900, Windsor Resort, featuring the hotels, a theater, and a recently opened amusement park, were well known. Dan Trimper purchased a Herschell-Spillman carousel in 1902 that is still in operation today. In 1920, the Trimpers also bought a smaller carousel and a kiddie Ferris wheel. The year 1958 saw the opening of outdoor rides, and, from 1960 on, a ride was added every year, bringing the total to about 50. A hot-air balloon ride is one of the most recent additions. In the above photo, part of the notorious roller coaster can be seen. Purchased in 1985, the Boomerang and Loop Roller Coaster are the most popular rides. Today, Trimper holdings include the park rides, a kiddie amusement area, a 14-store retail shopping village, restaurants, an arcade center, and a mini-golf course. Grandson Granville Daniel Trimper, at 70, continues to serve as the family patriarch, working many long hours in the 109-year-old amusement park, which employs about 300 people during the summers. The entire family has been involved in politics in some way as well as the family businesses. (Courtesy of Sunny Day Guides.)

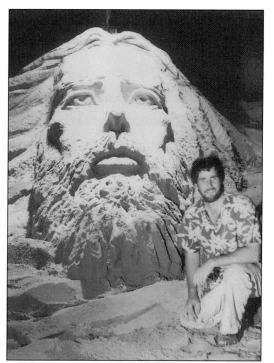

SAND SCULPTURE. Sand sculptor Randy Hoffman is known nationally for his creations; he has been written up in dozens of publications and has appeared on television and radio. Hoffman sets up nightly in front of the Plim Plaza Hotel at Second Street on the boardwalk, where he spends hours molding sand into biblical scenes with his hands, a plastic crab-picking knife, and a shovel. Sometimes a digging crew, comprised predominantly of local youth, assist him in between performing short skits and singing in costumes. When Hoffman, an ordained minister, completes his sculpting, which is specially lit in brilliant colors, he turns to the large audience standing on the boardwalk watching, and delivers a brief, open-air sermon while handing out tiny red Bibles. Amazingly, seldom does anyone destroy the sculptures and they remain intact for days, even as long as a week, when Randy returns to create anew. (Courtesy of R.C. Pulling/HPS.)

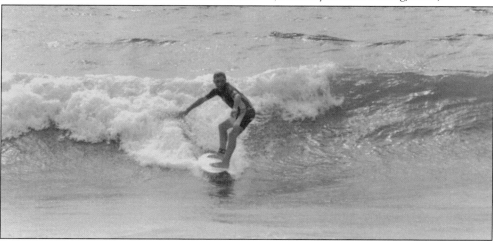

SURFING. This sport is so popular that a 32-year-old organization, the Eastern Surfing Association (ESA), exists to help young people learn the proper way to surf as well as to protect the interests of all surfers and maintain surfing areas in the resort. The group also helps raise funds for the ESA Marsh Scholarship program, donates ADA (Americans with Disabilities Act) beach wheelchairs to the city, and maintains an internet presence. The ESA's 6,000 members line the East Coast, Great Lakes, and Gulf of Mexico in 25 districts, and the association offers surfing competitions and a "Surfing Beach Program." Ocean City, a hot spot for this water sport, attracts surfers from all over the world. In the 1950s, Mayor Hugh Cropper brought one of the first surfboards to Ocean City. Jeff and Kathy Phillips of the ESA say that the resort is a "surf friendly" town with a supportive city government and beach patrol. In this July 1994 picture, Sean Robbins steadies himself as he rides a wave. (Courtesy of John Robbins of "62nd Street Logboardsers.")

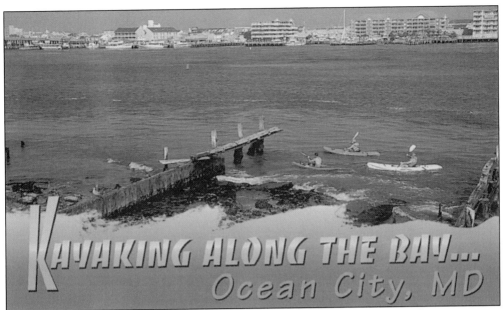

KAYAKING ALONG THE BAY. This photo shows happy kayakers on the bay side of the resort. Although not the same as whitewater kayaking, this popular form of boating in Ocean City offers the same thrills and chills. The use of wide bottom touring kayaks makes the boats very stable and safe to use, and with the new open-top cockpits, nature is at one's fingertips. (Courtesy of Roland Bynaker of Trade Winds.)

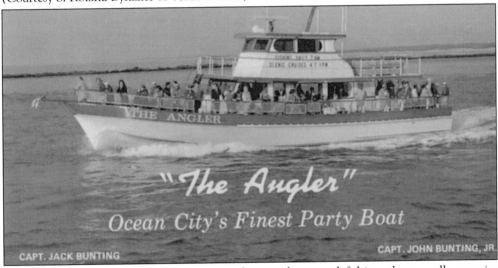

THE ANGLER. A restaurant and marina with party boats and fishing charters all comprise the Angler establishment at Talbot Street and the bay. The business has been owned by the Bunting family since its inception, beginning with Captain Talbot Bunting and Jack and John Bunting. It was later owned by Captain Charles Bunting and his five sons. Captain Bunting's son William built a fishing office in 1934 where his wife made homemade pies, and this became the seed of the restaurant. In 1945, William Porter (William's son) and his wife, Martha, made the business a joint venture with his parents. He retired in 1971. The company is now operated by William and Martha's daughters, Julie and Jayne. Dinner cruises are one of the highlights of the business, as is chartered fishing. (Courtesy of the late Fred W. Brueckmann.)

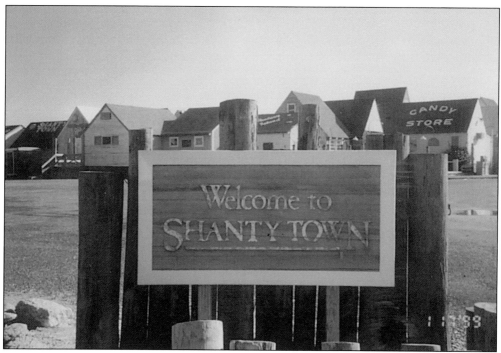

SHANTYTOWN. These photos show the entrance to the village at Route 50 and Shantytown Road in West Ocean City. Established in 1975 by Danny Trimper, Raymond Nichols took ownership of Shantytown in 1987. The site offers quaint stores on the water such as an ice cream parlor, a deli, crafts and collectible shops, designer fashion stores, flower shops, and a Christmas gifts store. A replica of Shantytown Lighthouse is also featured, as well as tour and cruise boats such as the *Miss Ocean City*. Below is a picture of the docks, looking from Shantytown toward the water.

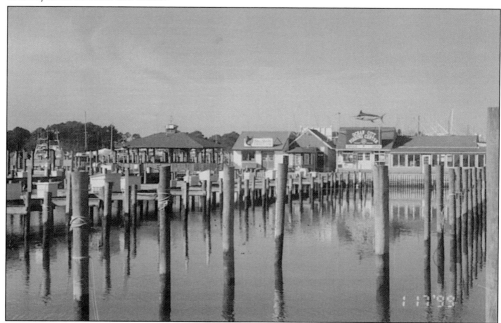

Five

FIFTEENTH STREET TO THIRTY-FIRST STREET

Fifteenth Street marks the beginning of the modern motel era, where rooms were rented and meals were a separate item, but a pool was a necessity. These motels were built on the boardwalk and stretched as far as it did; the restaurants became famous on their own. This area really started to develop after the state built the new highway running north. It caused confusion at first because its right-of-way did not follow Philadelphia Avenue, but gradually moved toward the ocean to create a new set of highway frontages.

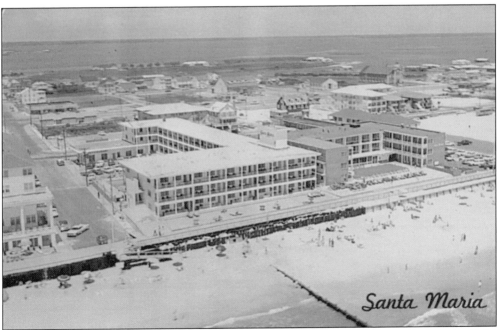

THE SANTA MARIA MOTOR HOTEL. In 1956, the Santa Maria was built on the boardwalk by George Bert Cropper, Incorporated, for Willye Jones Conner Ludlam. It was a three-story structure, except for the restaurant, the Captain's Table, on the southwest corner. The hotel provided 30 oceanfront rooms. (Courtesy of the late Fred W. Brueckmann.)

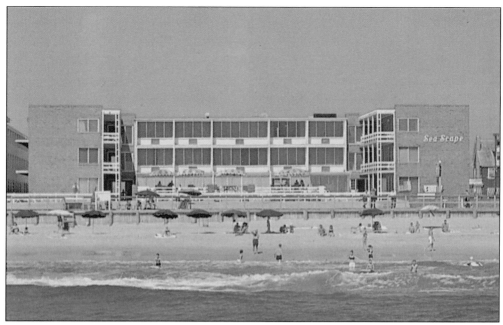

THE SEA SCAPE MOTEL. The first of the boardwalk motels, the Sea Scape was built in a flat "V" shape around a pool, and the rooms were supposed to be sound proof. The motel had three eateries, a coffee shop, the Tavern by the Sea, and the Neptune Room. (Courtesy of Aladdin Color Inc., Florence, New Jersey.)

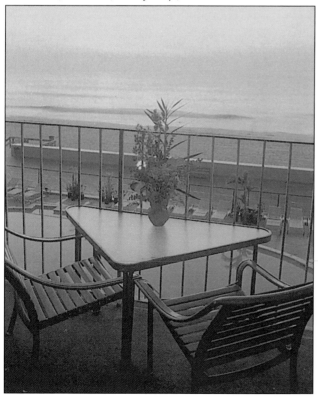

THE QUALITY INN BOARDWALK. The Quality Inn Boardwalk, located on the south side of Seventeenth Street, offered an outside and an inside pool, as well as a Jacuzzi, a sauna, a game room, a gift shop, and an oceanfront restaurant. This picture shows one of the porches on an oceanfront room. The inn is owned by The Harrison Group.

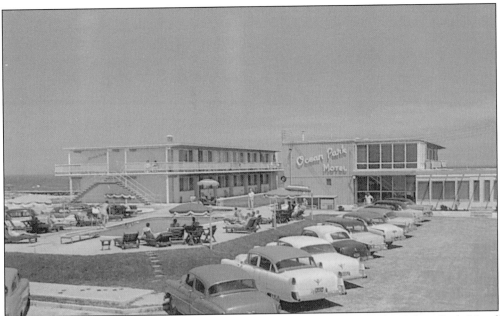

OCEAN PARK MOTEL. Built on the north side of Seventeenth Street, the Ocean Park Motel consists of two separate structures with a slightly elevated pool behind them, raising the pool above the level of the parking lot. (Courtesy of Chuck West.)

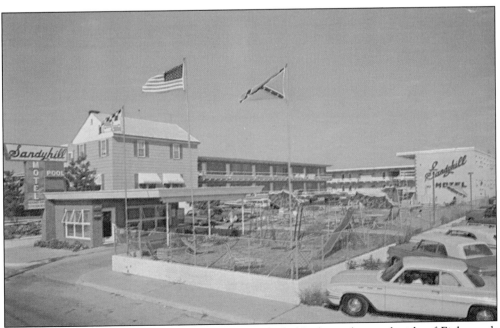

THE SANDYHILL MOTEL. This motel occupies a whole block on the south side of Eighteenth Street. The parking lot has taken over part of the children's play space, and we cannot swear that the Confederate flag still flies. (Courtesy of Aladdin Color, Inc., Florence, New Jersey; collection of David Dipsky.)

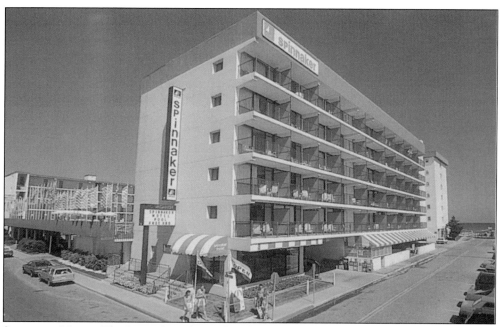

SPINNAKER MOTEL. The Spinnaker is located on the ocean side of Baltimore Avenue at Eighteenth Street. An impressive complex with its own coffee shop and indoor pool, the Spinnaker is owned by William Purnell. (Courtesy of Aladdin Color, Inc., Florence, New Jersey.)

THE SAHARA MOTEL. The Sahara , a beach front luxury motel on the boardwalk at Nineteenth Street, advertises that its customers have golf privileges. The owners of the Sahara have also acquired the Harrington Apartments, pictured on the following page, renaming them the Sahara West. A coffee shop has also been added in the renamed apartment building. (Courtesy of Pam Harrington.)

THE HARRINGTON APARTMENTS. Once independent, it has been sold to the Sahara and is now called Sahara West. It faces on Baltimore Avenue.

THE FOUNTAIN COURT MOTEL. The Fountain Court, located at 1900 North Philadelphia Avenue, was built by Irvin C. Bainum and later owned by Bill and Jean Fleming. Since then its name has been changed to the Cabana Motel, and its color scheme has also been changed to blue and white.

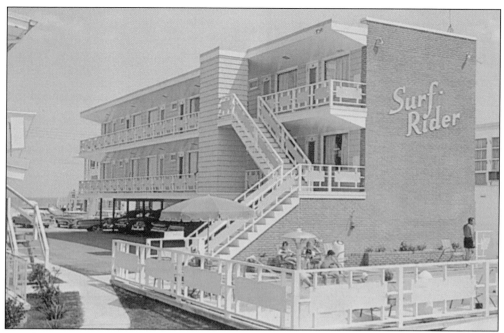

THE SURF-RIDER MOTEL. This small-sized motel at 2004 Baltimore Avenue was built in 1962 by Richard Wormans. The Surf-Rider also boasts a pool.

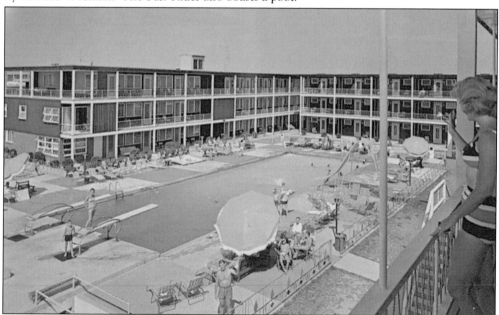

THE STOWAWAY MOTEL. Located at the junction of Twenty-second Street and the boardwalk, the Stowaway consisted of 52 units when it was first built but was later enlarged to 120 units. The swimming pool, cocktail lounge, and restaurant were part of the original structure. A third floor was eventually added, and the ocean side was filled in with units. The Stowaway buildings have been torn down and are being replaced by condominiums seven stories high. In addition, there are about a dozen stores doing business at the boardwalk level. (Courtesy of Aladdin Color, Inc., Florence, New Jersey, and the late Fred W. Brueckmann.)

THE SURF AND SANDS MOTEL. This motel extends from Twenty-second to Twenty-third Streets on the boardwalk. The Surf and Sands Motel has resisted change and is still doing business the way it has since it was built *c.* 1960s.

WESTWARD HO MOTEL APARTMENTS. Located on the bay side of Beach Highway at Twenty-third Street, this was originally a spacious motel, laid out on a number of acres on an offshoot of the bay as a two-story building. Now, the Westward Ho is a single five-story building, and the rest of its acreage has been sold off to developers. (Courtesy of the late Fred W. Brueckmann.)

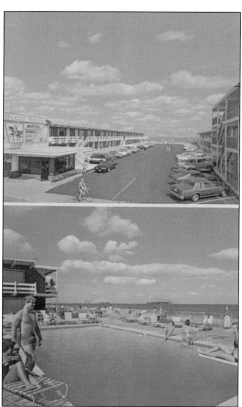

THE OCEAN MECCA MOTEL. Found on the boardwalk at Twenty-third Street, this building is only 15 years old. In the spring of 1999, the motel was getting a handsome new face and is now a Day's Inn. (Courtesy of Aladdin Color, Inc., Florence, New Jersey.)

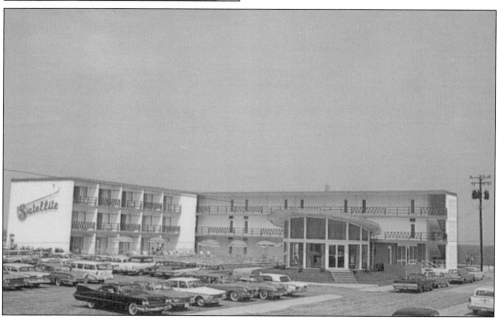

THE SATELLITE MOTEL. This postcard describes the Satellite Motel at Twenty-fourth Street on the boardwalk as the "newest among the new," but the building's lack of age didn't save it. The Satellite was torn down and a Howard Johnson erected in its place, occupying the former parking lot.

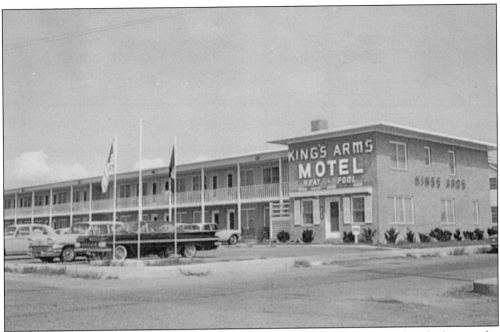

THE KING'S ARMS MOTEL. Located at Baltimore Avenue and Twenty-fourth Street, the King's Arms Motel was built in 1960 by Dorothy H. Taylor. Occupying a block of land, the motel is now owned and operated by Mr. and Mrs. Hugh Cropper. (Courtesy of the late Fred W. Brueckmann.)

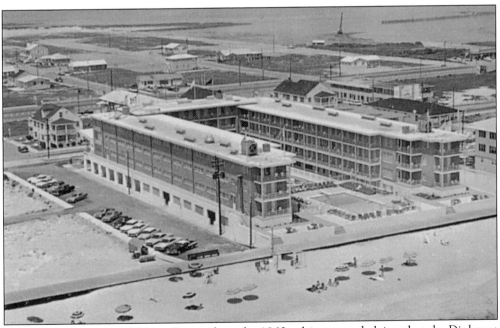

THE DIPLOMAT MOTOR HOTEL. Dating from the 1960s, this postcard claims that the Diplomat Motor Hotel, built on the boardwalk between Twenty-sixth and Twenty-seventh Streets, had "the largest and most luxurious rooms on the Beach." You can see from the view that when the hotel was built there was a lot of vacant space in the area.

THE NEW BEACH HOTEL. This is how the New Beach Hotel looked when it was first built as a single-story motel at Philadelphia Avenue and Twenty-sixth Street. (Courtesy of David Dipsky.)

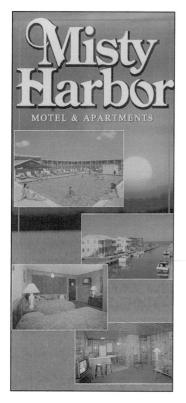

THE MISTY HARBOR MOTEL. Rebuilt and with a second story added, the Misty Harbor Motel has been upgraded into a first-class complex with boating and fishing privileges and a pool. The hotel is now owned and operated by Troy Purnell. (Courtesy of Aladdin Color, Inc., Florence, New Jersey.)

THE BEST WESTERN FLAGSHIP OCEANFRONT. This is how the large and luxurious rooms looked after the Best Western was remodeled. The hotel now sports the Jonah and the Whale dining room, which advertises an unbeatable, all-you-can-eat seafood buffet. (Courtesy of the late Fred W. Brueckmann.)

THE RIVIERA MOTEL. At Twenty-sixth Street and the ocean, the Riviera brags that its rooms are both fireproof and sound proof. It runs through the block to Baltimore Avenue. Still operating, the Riviera Motel advertises free in-room coffee. (Courtesy of Bill Bard Associates.)

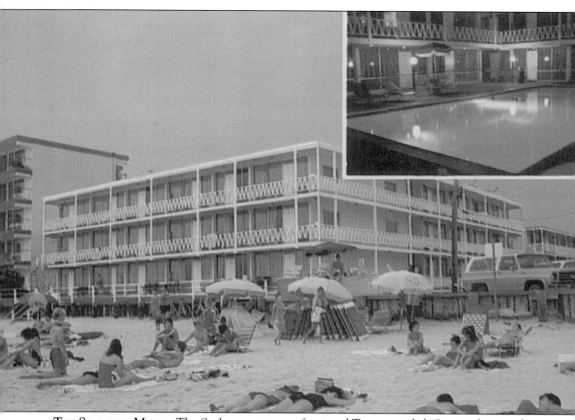

THE SEABONAY MOTEL. The Seabonay, at oceanfront and Twenty-eighth Street, claims to have been named after a French song. It is advertised as being located at the end of the boardwalk, a view that this parked car supports. The insert shows an indoor pool. (Courtesy of Sara Melson Photography; collection of David Dipsky.)

Six

Dining, Dancing, and Nightlife

Though prior to 1947 the city provided resort visitors with various entertainments, the town didn't truly come into its own until after World War II. New forms of recreation developed after the war, such as the Easter celebration and parade, beauty contests, festivals, and even baseball. But one of the most favored forms of enjoyment was dining, and that only kept getting better as the resort continued to grow. Today, the traditions of dining and entertainment continue in Ocean City, although one's "Sunday best" is likely to be replaced by blue jeans, tennis shoes, baseball caps, and T-shirts. Yet the flavor and the fun continue. New restaurants popped up everywhere, especially with the advent of the motor hotels (now called motels), which didn't serve food. Some provide well-known and live entertainment; others tender the latest in high-tech television viewing while munching. Still others have gained a reputation for certain types of food such as Thrashers' French fries, Fager's French onion soup, Phillips' crabs, Hanna's breads, and so on. But whatever your desire is, whether a dressy dining spot or a dress down bar, seafood or pasta, pizza or pancakes, a quiet atmosphere or loud bands, the resort has it.

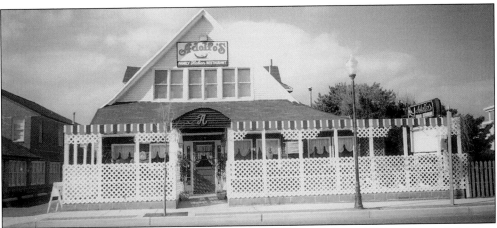

ADOLPHO'S. This house has a long history of ownership. Built in 1881 at South Baltimore Avenue, it served as the first Episcopalian church. Then, in 1900, when Christopher Ludlam purchased the structure, parishioners used the proceeds to finance a new church on Baltimore Avenue and Third Street. The Harry Kachell family eventually took possession of the building until it was purchased by the Espositos in 1969. It then fell to their daughter, Nancy Sacca; she began renting the building to Jerry Kuczinsky in 1987, and he turned it into Adolpho's Restaurant. Italian food is its staple, and the restaurant caters to a large patronage.

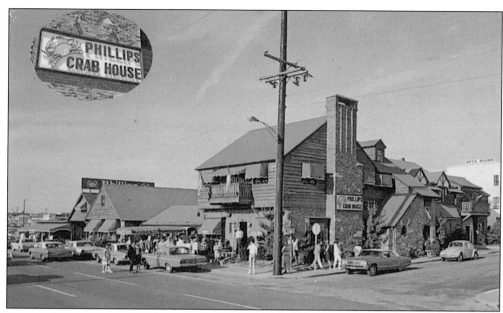

PHILLIPS RESTAURANTS. Shirley and Brice Phillips opened a steamed crab shack on Twenty-first Street (above photo). It was such a hit that, for the next dozen years, the Phillips had to add on dining rooms. Currently, this location has 6 kitchens and 12 dining rooms with a staff of 400 and a seating capacity of nearly four times that. In 1956, the couple opened Phillips Crab House; in 1973, they acquired the Beach House Hotel and its dining room. Four years later, they unveiled Phillips Seafood House and Carry Out on 141st Street; in 1980, they embarked on Phillips Harborplace in Baltimore, Norfolk's Waterside, and Washington's Potomac restaurants, and, later, a restaurant in West Palm Beach. Today, the Phillips' holdings include nine restaurants, two hotels, and six seafood packaging plants worldwide. The Phillips interview thousands of potential workers and employ several hundred during the summers in Ocean City. They own several apartment buildings for their college-aged workers. They have a son, Jeffrey, and their older son, Stephen, and his wife run the family business. The photo below was taken in 1998. (Above courtesy of Brooks Photography.)

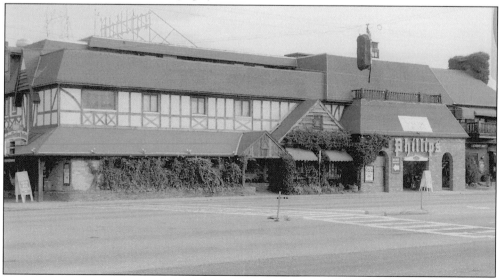

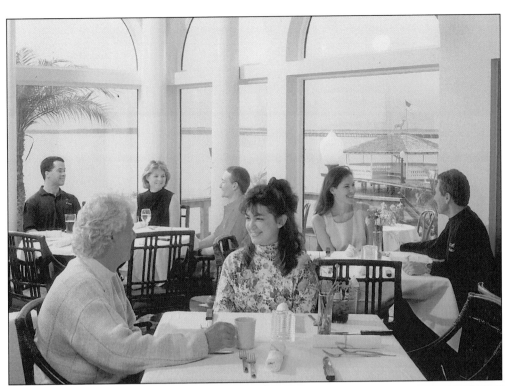

FAGER'S ISLAND RESTAURANT. John Fager opened a bar on the bay side in 1975 that turned into the famous and oldest northern bayfront restaurant, employing 200 staff in the summer and seating 800. The restaurant's interior has been fashioned by New York City designer Lawrence Peabody and features original Haitian art by Jasmin Joseph. General manager Charlie Smith points out that, in the last 25 years, the restaurant has undergone numerous renovations, including the addition of dining areas, a wine cellar with a steward, and a second floor with many accouterments. The establishment, which has been written up in numerous national and international magazines, is known for its victory party for the "Oceanic Cup" awarded to the best lifeguard, wine-tasting parties that draw people from all over the globe, and celebrity diners that have included Sissy Spacek, Kevin Kline, Richard Gere, and former Vice President Spiro Agnew. The restaurant has its own beer and wine labels that are produced with a vintner in France considered by "Wine Spectator" to be in the top 100 in the country. Fager's 80 varieties of beer have prompted three clubs: The Hall of Foam, Around the World in 80 Beers, and Ninety-nine Beers on the Wall. (Courtesy of C. Smith of Fagers Island Restaurant.)

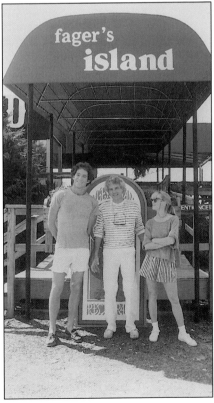

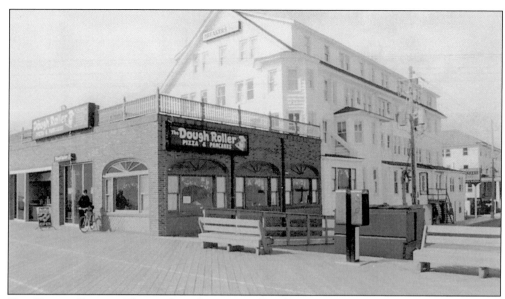

THE DOUGH ROLLER. The sand got between Bill Gibbs' toes well over 37 years ago when he worked at the Breakers Hotel on Third Street and was constantly asked by tourists, "Where's the best place to eat?" So about 20 years ago, Bill and his wife, Julie, bought the Breakers and transformed the porch into the Dough Roller. Pancakes and pizza are their main staple, but they also offer subs, sandwiches, pasta, and other items. The restaurant on the boardwalk eventually grew to two restaurants when another eatery was opened at South Division Street in 1985, to three in 1988 (Seventieth Street), to four in 1994 (Forty-first Street), and to five around 1995 (Crofton, Maryland). A sixth location is in the making in North Ocean City. In this 1998 photo, one can see the first restaurant in the chain. The former porch of Breakers' Hotel is the restaurant. (Courtesy of Bill Gibbs of the Dough Roller.)

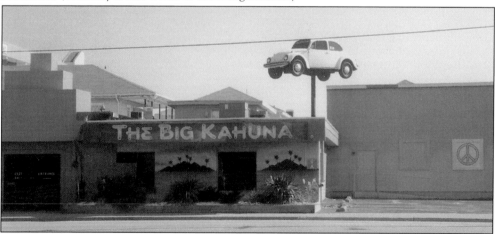

THE BIG KAHUNA. A large sign over this building reads "3 Clubs in One." This photo features a structure that's been in existence since 1955 as the Paddock on Seventeenth and Eighteenth Streets. Then, in 1987, half the building became the Big Kahuna, which suited surfers and "beachers." The Kahuna features all types of Party Rock, from DJ Liquid to AC/DC and Jimmy Buffett. The Volkswagen Bug is symbolic of the 1960s era when the Big Kahuna rode the "Big Wave" and drove a yellow bug. The 1,000-pound car is gutted inside and was hoisted by crane to its towering position in 1975.

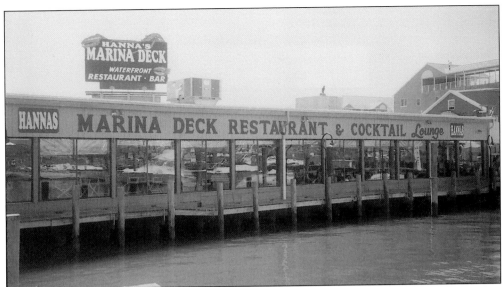

The Hannas Marina Deck Restaurant. Famous for its daiquiris, darts, billiards, and sports, the jetty bar of the restaurant was originally opened in 1978 by Buddy and Frank Hanna. This restaurant on Dorchester Street has become a staple for Ocean City visitors and celebrities worldwide. Owner Frank Hanna offers, "Every Maryland governor has eaten here, as well as sports Hall of Famers, supreme court judges, and movie stars. The TV commercial that Sissy Spacek and Kevin Kline filmed for Ocean City was taken here. And we offer the best view of the bay." Although well known for its homemade coconut muffins and fresh seafood, the 350-seat restaurant also offer steaks, veal, and chicken. In addition to owning the block-long eatery with docks, Hanna Systems also runs Harpoon Hannas in Ocean City, built in 1983, as well as commercial and residential real estate on the Eastern Shore. This picture shows the waterside of the restaurant. (Courtesy of J.R. Hayes.)

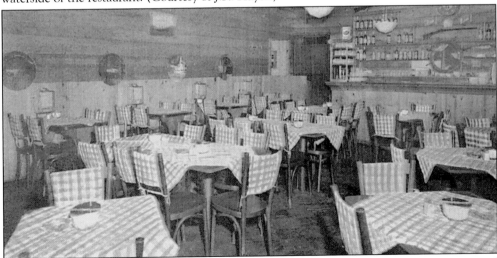

The Knotty Pine Restaurant. Owned by Doris and Lester Wise, this restaurant, pictured c. 1955, offered meals from sandwiches to full-course dinners. Notice the checkered tablecloths, knotty pine walls, and old wooden tables that are reminiscent of a lively bygone era. Even the salt and pepper shakers and other accessories harken back to the mid-1950s and early 1960s. (Courtesy of Tingle.)

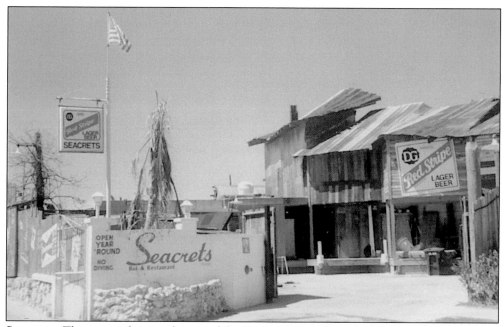

SEACRETS. This image shows only part of the Seacrets' complex, which houses 140,000 square feet of eating space, dancing areas, and ten bars. It offers nightly live performances. This Jamaican-styled nightclub/eatery, which was originally a private club, is decorated with palm trees and tiki torches. In its fifth year of operation, Seacrets added more bars, and its beach area nearly doubled in size, allowing patrons to float on rafts while having drinks. Now in its tenth year, Seacrets continues to grow as its patron base broadens, but its unusual theme remains the same.

PALACE RESTAURANT. This dining spot's interior is reminiscent of the era of the 1950s with its chrome tables and chairs, old sugar containers, and walls done in paneling and chrome. Located at South Baltimore Avenue, the diner-like restaurant boasted spaghetti and ravioli, along with seafood and "tender, juicy steaks." (Courtesy of MWM Co.)

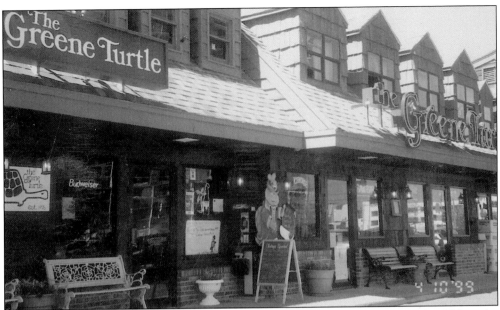

THE GREENE TURTLE. The Turtle, located at 116th Street, opened on June 18, 1976, under the ownership of Mike Holden and Phil Anthony; it was a small pub seating only 50 and had bookshelves and inlaid backgammon boards. In 1981, Tommy Dickerson and Steve Pappas bought the business; both men had worked at the Turtle since its opening. Around 1997, Pappas became sole owner, but, in February 1999, Steve and Tommy opened a new Greene Turtle in West Ocean City. Two other Turtles also exist in Fells Point in Baltimore and in Laurel, Maryland. The Turtle's owners have been friends since the 1970s, when they met while attending Salisbury State University. The Greene Turtle is known for its good food, peanuts on the floor, 20 television sets and 60-inch big screens, nightly live entertainment, cigar bar and humidor, and an expanded upstairs game room. This photo shows the Turtle at 116th Street and Coastal Highway.

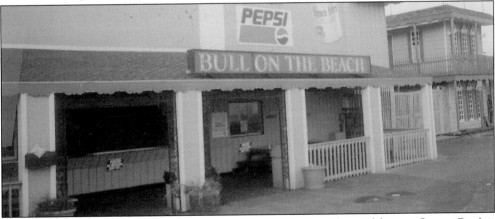

BULL ON THE BEACH. Open pit dining is what this restaurant (one of four in Ocean City) is known for, and the chefs think nothing of dumping 500 pounds of beef, chicken, and ribs into the barbeque pit. Owners Maria and Phil Houck own a patent on the pit, which they personally designed. Maria says they were the first to cook with an open flame and an open grill inside. Seafood and a fresh raw bar are also part of the restaurant's fame. Established in 1980, the business is still family owned.

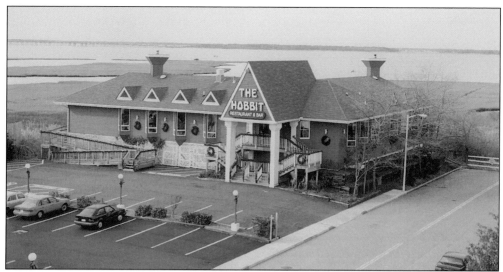

HOBBIT LOUNGE AND CAFÉ. Established in 1977 by Tom Hierderman and still owned by him, the Hobbit is known for its live entertainment and as a hot spot nightclub that offers family and fine dining. Perhaps the restaurant is so named because hobbits enjoy fine meals and laugh deeply after eating, but, for the real story, study the hand-painted bar top that narrates J.R.R Tolkein's tale of the Hobbit. In any case, whether served by hobbits or humans, this restaurant on Eighty-first Street offers fine food and entertainment. (Courtesy of Tom Hierderman of the Hobbit.)

NITE LITE. This recent photo gives a sense of what this popular "under 21" nightclub looks like. Owned by John Woyt, who is originally from the Pittsburgh area, the dance club with a disco atmosphere opened in 1986 in the old Capital movie theater, its last showing *The Planet of the Apes*. Woyt's establishment offers "the kind of music the kids want from hip hop to swing to rock." To keep the place safe for all youngsters, Woyt makes sure none of his guests bring in drugs, alcohol, or weapons; he and his staff search bags, backpacks, and the like. "We've never had a problem inside the club," says Woyt.

Seven

THIRTY-FIRST STREET TO SIXTY-SECOND STREET

With images of places clustered around Ocean City's convention center, this chapter focuses on an area that is heavily built up on the bay side but not so completely on the ocean side of Beach Highway. It also includes the last few blocks of Baltimore Avenue.

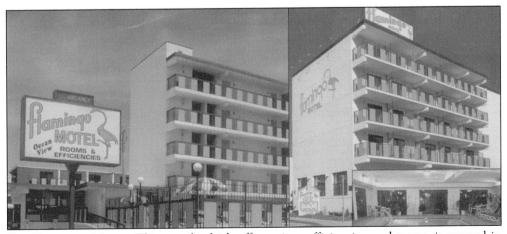

THE FLAMINGO MOTEL. This motel, which offers suites, efficiencies, and rooms, is unusual in that all the buildings are not the same but share the same address (3100 Baltimore Avenue). The pool and one building were photographed separately on this postcard.

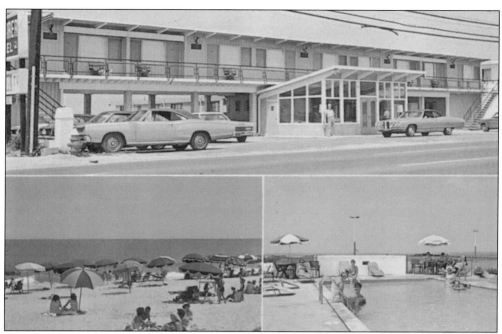

THE SEAFARER MOTEL. This motel was built on the west side of Philadelphia Avenue at 3101 North Beach Highway. No longer there, it has been absorbed into the Jolly Roger Amusement Park. (Courtesy of the late Fred W. Brueckmann.)

QUALITY INN BEACHFRONT. This image shows the new building on Thirty-third Street. The hotel's address is 3301 Atlantic Avenue, which means that it is an oceanfront property. The bird, which is still alive, is the Beachfront's mascot. The hotel offers two-room suites with two-person hot tubs.

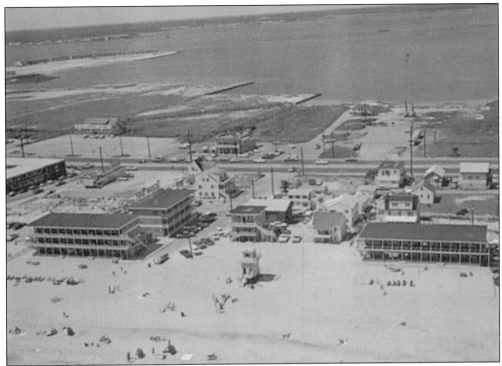

OCEAN SIDE. This postcard shows Thirty-fourth and Thirty-fifth Streets on the ocean side. The little house in the center of the picture was the original building built by the Abbots. The bird's-eye view tells the story of the development of Thirty-fourth and Thirty-fifth Streets. The house in the center of the picture was first built in the 1950s. It faced the ocean, had a dirt street leading to it, and had a septic tank under the floor, but it was not within the city limits. Later, when the building did officially become part of the city, the street was paved. The building to the left, built by Mr. and Mrs. Alger Abbot, was later sold to the Quality Inn Beachfront. (Courtesy of the late Fred W. Brueckmann.)

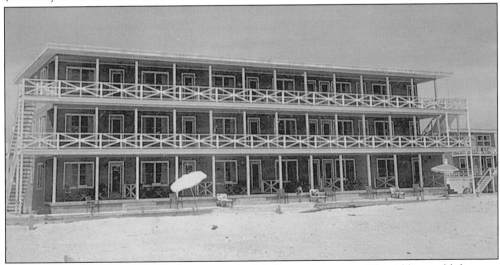

OCEAN SIDE II. This building is the one on the left facing the ocean. The Abbots sold this part of their holdings to the Quality Inn.

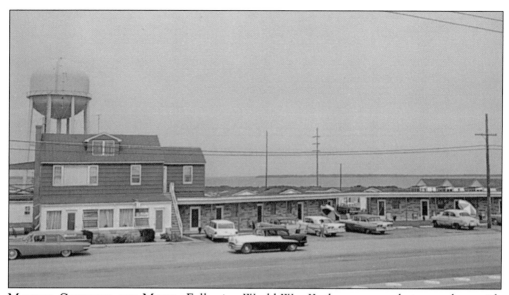

MARIDEL COTTAGES AND MOTEL. Following World War II, there were only two realtors with offices north of the limits of Ocean City (Charles Holland and Ray Jarvis). Holland also owned the motel pictured here and told the following story of his motel activities. When a busy weekend rolled around, Holland would turn on the "no vacancy" sign on his motel. Then, later, the vacancy sign would be lit. It remained on until late afternoon, when Holland could extract a higher price for his rooms. This picture dates from the early 1950s. (Courtesy of the late Fred W. Brueckmann.)

THE BEACHCOMBER. This cottage on Forty-third Street, built facing the ocean, was, at some point, divided into two apartments and was located behind another building. Finding the Beachcomber required detective work. (Courtesy of the late Fred W. Brueckmann.)

CASTLE IN THE SAND MOTEL. John Dale Showell bought the entire block situated between Beach Highway, Thirty-seventh Street, and Thirty-eighth Street on which to build his motel. As his motel prospered, Showell kept plowing his profits back into building improvements and additions until he had a full-fledged hotel, apartments, cottages, a pool, and a patio. When his business venture finally seemed complete, Showell died, leaving a huge legacy and responsibility to his family. (Bottom photo courtesy of Ogden & Associates.)

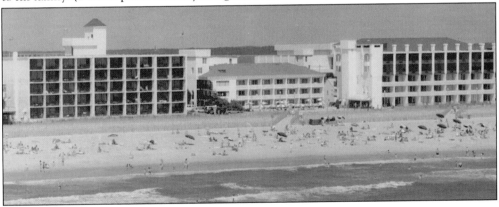

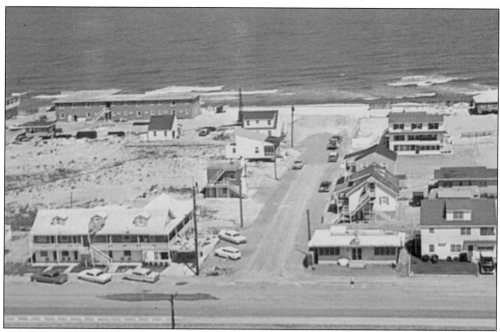

THE SUN AND BEACH APARTMENTS. This postcard showing Forty-fifth Street also shows the Sun and Beach Apartments on the lower left hand side. The deeper shade of color on both sides of the street is the original clay that the owners of the land on the street put in at their own expense. The building in the upper left of the image, facing the ocean, was the Salty Sands. After seeing this card, the first words spoken by the owner of the Bistro (located to the right of the streets) were "The roof didn't leak then." (Courtesy of the late Fred W. Brueckmann.)

THE SALTY SANDS MOTEL. Located at Forty-sixth Street on the ocean, these apartments are still standing, but the name has been changed. The Salty Sands was rebuilt and the name changed to the Windjammer. (Courtesy of the late Fred W. Brueckmann.)

"Your Children-Our Pleasure"

THE GORDY HALL MOTEL. Located once at Forty-fifth Street and Beach Highway, the Gordy Hall Motel is now gone, having been replaced by the Forty-fifth Street Shopping Mall around 1976. The building partly shown at the left edge of this postcard, however, belongs to the city and is still there. The buildings shown on both sides have been converted into stores and feature a variety of roof lines and storefronts. An addition was made on each side of the structure as separate stores were built. The building in the center was either removed or moved toward the bay and converted into a restaurant. The developer filled in the pool but later decided to add a flagpole. When the developer drove down through the dirt, he struck concrete (not oil) and had to drill through it before the flag could wave over the heads of shoppers. (Courtesy of the late Fred W. Brueckmann.)

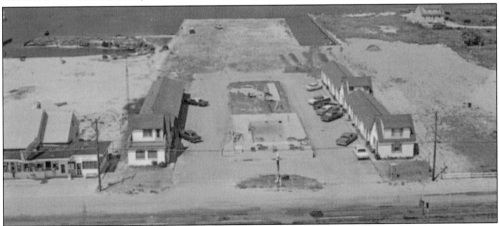

THE SUNSET VIEW MOTEL. This is the way the Sunset View Motel looked shortly after it opened in 1950. It was opposite Forty-ninth Street, which only runs from the ocean to Beach Highway, and there is a dredged-out boat harbor on the left and a straight cut inlet on the right. Presently, the Bayside Princess Hotel stands on the highway with the Wight Condominiums erected behind a separating alley. The land is now completely occupied by buildings, garages, and other appurtenant structures. (Courtesy of the late Fred W. Brueckmann.)

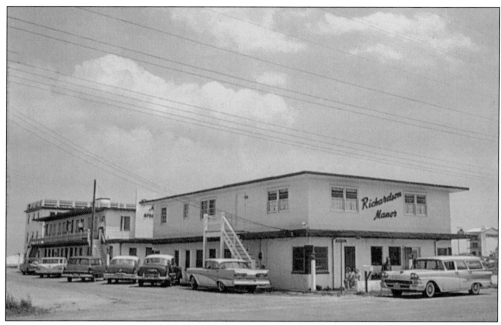

RICHARDSON MANOR. If you look for the Richardson Manor at Forty-ninth Street and Beach Highway, you may miss it since it is now the property of the Ocean Club. This building and the one behind it are still there, but this building now sports a lighted sign advertising the Ocean Club. The parking lot for the Ocean Pines Club is on the north side of Forty-ninth Street.

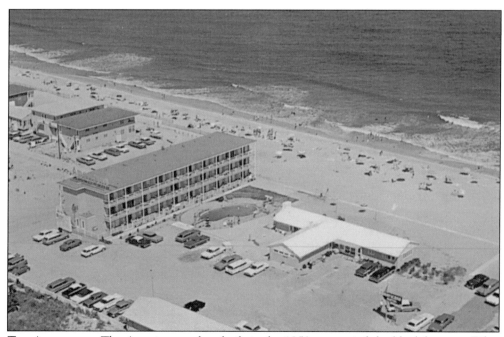

THE AMERICANA. The Americana, when built in the 1950s, occupied the block between Fifty-fourth and Fifty-fifth Street. It has now been replaced by the Quality Inn at Fifty-fourth Street, which reaches even further toward the sky. (Courtesy of the late Fred W. Brueckmann.)

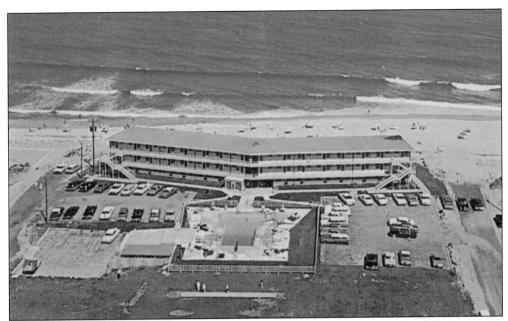

THE PARK DE VILLE APARTMENT MOTEL. Located on the oceanfront and Fifty-fifth Street, the Park de Ville Apartment Motel was originally owned by Irvin Bainum. It was built in a slight "V" shape and had three stories.

THE QUALITY INN AT FIFTY-FOURTH STREET. The Harrison Group, this site's present owners, built a new six-story building attached to the old building on the ocean side. This card shows the connection between the two structures. The pool is in the same location and has the same shape.

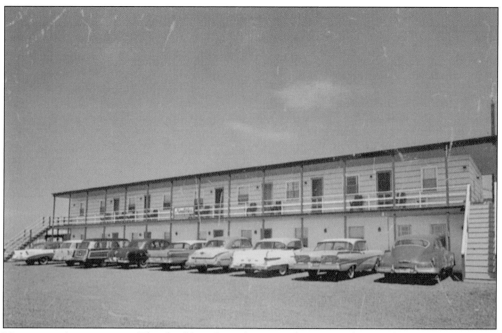

NAUTILUS APARTMENTS. This building has also ceased to exist, having been replaced by a condo complex called the Tiffany by the Sea on the ocean side of Fifty-fifth Street. (Courtesy of Chuck West; collection of David Dipsky.)

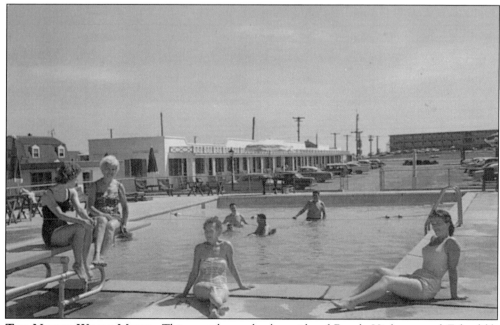

THE NORTH WINDS MOTEL. This motel, on the bay side of Beach Highway and Fifty-fifth Street, is now the Sunset Motel. The pool is located behind the double line of motel rooms.

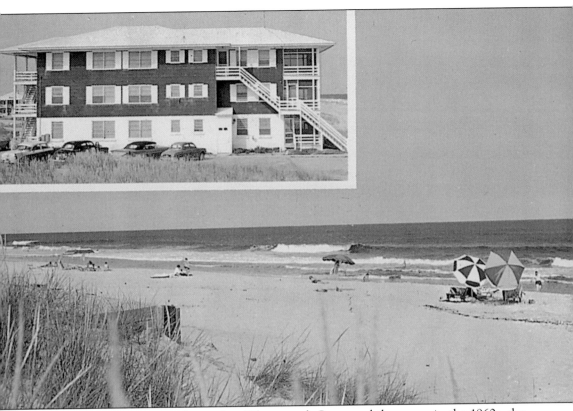

The Skylark Apartments. Located at Fifty-seventh Street and the ocean in the 1960s, the Skylark Apartments has been changed into six condo units. When the conversion was made in the 1980s, the condominiums' owners must have acquired the back half of the lot behind the Mariner because the lots bear their names. (Courtesy of the late Fred W. Brueckmann.)

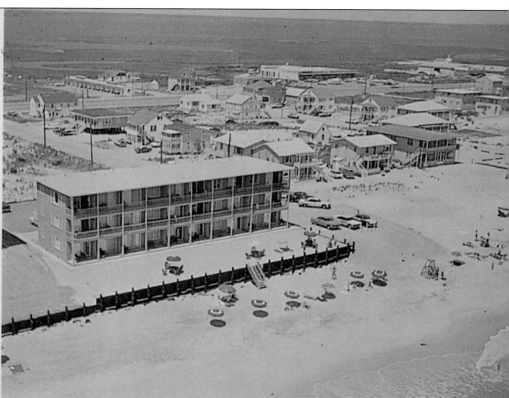

THE WEATHERVANE. This apartment has been torn down and replaced by the six-story La Mirage, and the only thing still remaining is the sea wall on the south side of the building. The building codes in Ocean City prohibit any new wooden buildings in Ocean City taller than three stories, so the Weathervane had to go. (Courtesy of the late Fred W. Brueckmann.)

Eight

KEEPING THE FAITH

Despite the fact that Ocean City is known for being fun land, it also offers numerous options for religious worship, and many natives and vacationers take advantage of the variety of places to attend services. Prior to the 1950s, only the traditional religions had chapels or churches in the area, and many of those were open only during the summer months, when the resort had its greatest population. By the 1950s, however, other faiths had begun making their home in the resort; some of these groups had started in the town and then moved elsewhere, only to come back again. The majority of the churches in the resort today are open year-round.

As the new millennium approaches, nearly every faith is represented in the small town, from Mennonite and Greek Orthodox to the conventional Baptist, Lutheran, Methodist, and Catholic faiths. In addition to Sunday services, several of these groups offer special activities to help strengthen one's faith. Such events include retreats, boardwalk performances, and even flea markets.

Unless otherwise noted, all photographs are offered through the courtesy of Kenna Brigham and Carol Hussey.

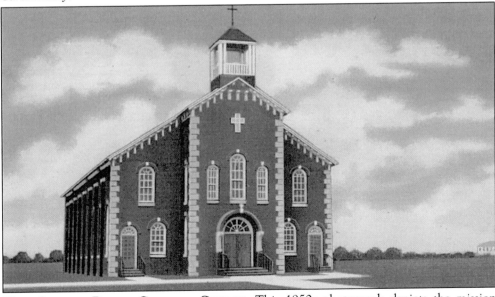

HOLY SAVIOUR ROMAN CATHOLIC CHURCH. This 1950s photograph depicts the mission church of St. Mary Star of the Sea that was founded in 1954 by Monsignor Eugene Stout on nine lots between Seventeenth and Eighteenth Streets. The church has a seating capacity of 1,200. Over time, the swell of Catholics in the resort resulted in the congregation expanding enough to add on classrooms, a parish office, and meeting rooms. (Courtesy of the Harry P. Cann & Bros. Co.)

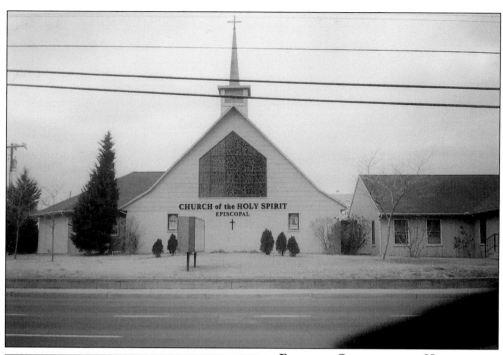

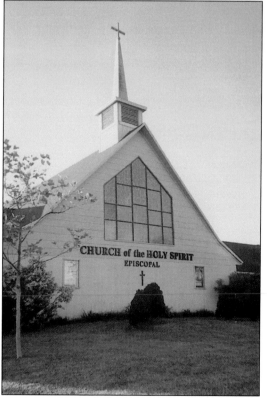

EPISCOPAL CHURCH OF THE HOLY SPIRIT. Located at 100th Street and Coastal Highway, this place of worship was formed in 1968 as a chapel of St. Paul's-by-the-Sea Episcopal Church of Ocean City in the Diocese of Easton. Until 1988, when Holy Spirit became a year-round church, the chapel was open only during the summer for vacationers. A parish hall was added in 1991, the same year that Holy Spirit became a self-supporting church. There was further expansion in 1993. The church, which has a "come as you are" dress policy, has various worship services and activities for children, youth, and adults. Currently there are about 400 families on the church's mailing list.

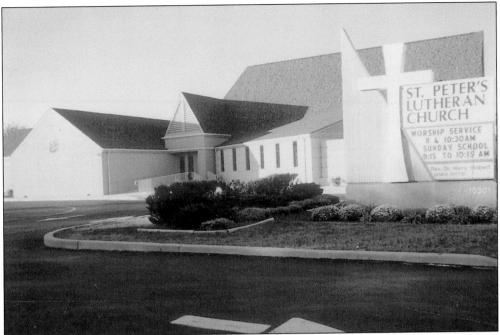

St. Peter's Lutheran Church. Located at 10301 Coastal Highway, St. Peter's was established in 1980 by Pastor Rudolph Barr. Before the construction of this building, parishioners held services at the resort's convention center. The congregation offers numerous activities and has an active musical praise group called Free Spirit.

Son'spot. Founded in 1981, this informal ministry is located at 12 Worcester Street, where the Spirit Life Full Gospel Church meets every Sunday. There has never been a permanent pastor, and many mission members take center stage to discuss their spiritual beliefs, if they are so moved. There are no rigid rules or policies. Attendance varies from week to week since there is no required membership, but on the average 1,000 people meet every week during the summer months.

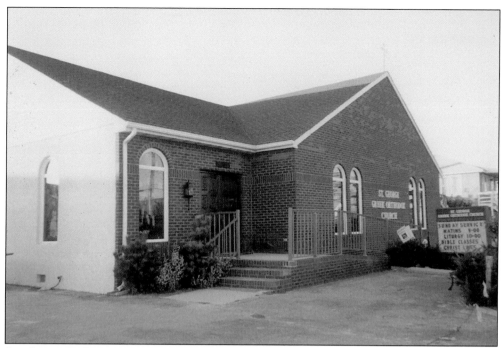

ST. GEORGE'S GREEK ORTHODOX CHURCH. This congregation has always been at its current location of 8805 Coastal Highway. In existence for the last 16 years, the church has grown enough to warrant expansion that will increase the size of the church building as well as provide classrooms, offices, and a kitchen. The church's Greek Fest, a popular three-day festival where good food and lots of dancing and entertainment are featured, attracts thousands yearly to the resort.

THE OCEAN CITY MENNONITE CHURCH. Located at 11811 Ocean Gateway, this church, founded in 1983, was originally situated two blocks east in a garage (its first meeting place). When the congregation outgrew its home there, the church was built at its present location, where it is refuge to 60 or 70 worshippers, of whom more than one-third are deaf.

94

ST. ANDREW'S CATHOLIC CHURCH AND ST. LUKE'S CATHOLIC CHURCH. In 1985, Father Richard Gardiner founded St. Luke's and St. Andrew's Churches as the second Catholic "parish" in Ocean City, since both were previously part of the St. Mary/Holy Saviour Parish. St. Luke's is located at 100th Street and Coastal Highway; St. Andrews is at 144th Street. Over time, such additions as a fully equipped kitchen and a religious education center were attached to the St. Andrew's part of the structure. Later, because of tremendous growth, St. John Neumann Church was built in nearby Ocean Pines in 1995. St. Andrew's is open only from Easter Sunday through September, while St. Luke's and St. John Neumann are open year-round. St. Andrew's Church is featured above, and St. Luke's is below.

THE MODERN FIRST PRESBYTERIAN CHURCH. This photo shows the modern brick structure built by the First Presbyterian Church in 1963. Originally, meetings were held in order to form a congregation in 1891. After using a series of buildings for worship, including a saloon, and finally erecting a church on North Division Street, the Presbyterian congregation constructed this building on the corner of Philadelphia Avenue and Thirteenth Street. The First Presbyterian's former home was purchased by the Baptists. The interior of the chapel is in the shape of an inverted boat, so that if you were sitting in the pews and looking at the ceiling, you would feel as though you were seeing the interior of a water vessel. Notice the shape of the roof in the photo and how it is molded into an upside-down ark. The stained-glassed windows were replaced in 1996. Currently, the church has 225 members who sponsor rummage sales, women's circles, and other spiritual activities.

Nine

SPORT AND COMMERCIAL FISHING

The federal government imposed new restrictions on sport fishing on June 1, 1999. The National Marine Fisheries Service said such restrictions were necessary because overfishing had caused a tremendous drop in the number of some species of shark, swordfish, and the white marlin. The number of fish allowed to be caught has been reduced to one per day per vessel. This makes the cost of fishing prohibitive unless fishermen are content to release all but one of their catch.

Commercial fishing has already had to undergo restrictions. The cost of clamming licenses has reduced the number of licensed boats. Bay line fishing to catch blue fin tuna and commercial catches of seacoast shark have also been affected. Only time will tell how these restrictions will reduce the number of fish caught and what effect this will have on the fish population.

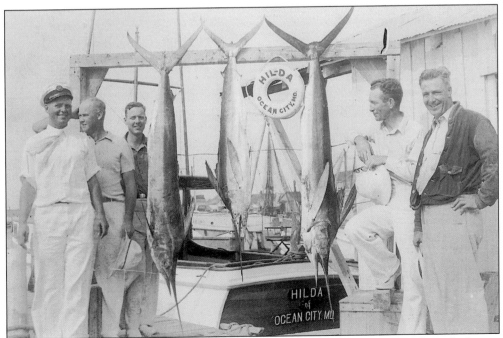

MARLIN FISHING. This picture was taken in the early days of white marlin fishing. It depicts Crawford Savage, a local fisherman who once got President Roosevelt to Ocean City, in his boat with three white marlin. (Courtesy of W. Quigley Bennett.)

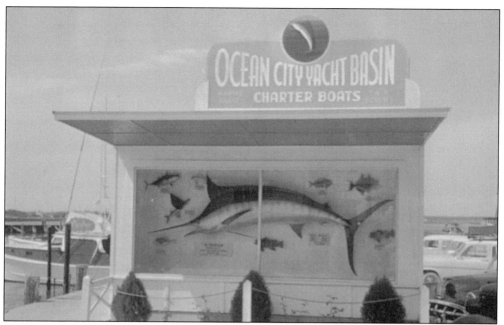

THE OCEAN CITY YACHT BASIN. In the center of this display is a 416-pound blue marlin boated in July 1953. Are those days gone forever? Will the marlin become a symbol of a bygone age?

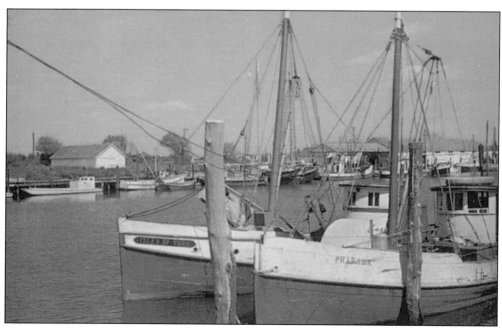

COMMERCIAL FISHING BOATS. The number of these boats may suffer a sharp decrease with the new restrictions and catch limits, but these restrictions found little opposition among Ocean City captains. (Courtesy of the Harry P. Cann & Bros. Co.)

OCEAN CITY, MARYLAND, WHITE MARLIN CAPITAL OF THE WORLD. The type of boat shown here may become rare in Ocean City and this picture of a blue marlin hard to duplicate in the future.

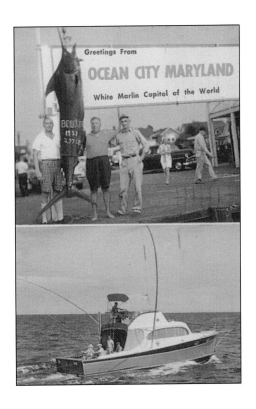

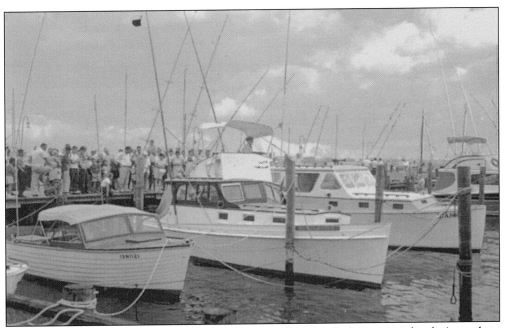

THE DAY'S CATCH. It will be hard to attract a crowd to the docks to view the day's catch in the future. The flags indicate that several of the fishing boats shown have been successful. (Courtesy of *Mardelva News*.)

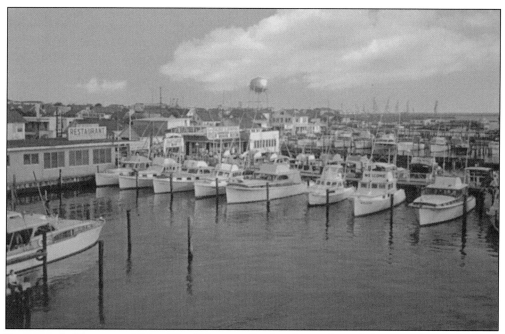

FISHERMEN'S PARADISE. This will still be paradise for the in-shore fisherman. It is only those who seek game fish in the ocean deep that will be affected by the new regulations. (Courtesy of *Mardelva News*.)

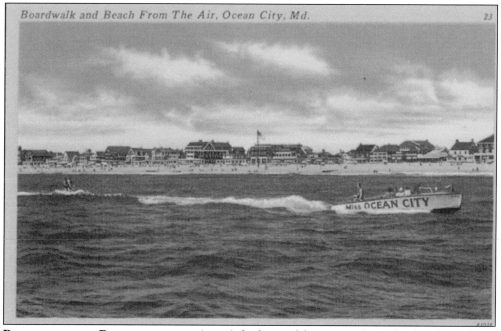

Boardwalk and Beach From The Air, Ocean City, Md. 23

BOARDWALK AND BEACH FROM THE AIR. A high-speed boat trip along the beach is always enjoyable. This was a high-powered speed boat that gave rides for a price, usually late in the afternoon. (Courtesy of Edward Stores.)

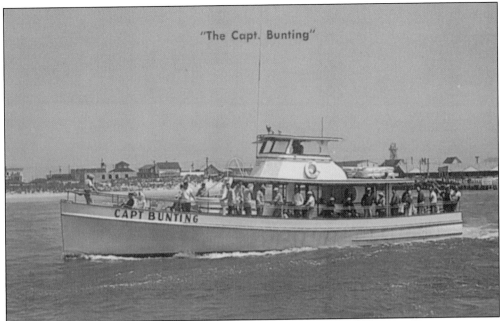

THE CAPTAIN BUNTING. Bottom fishing with bait and handlines furnished will still be available on a daily basis far into the future. (Courtesy of the late Fred W. Brueckmann.)

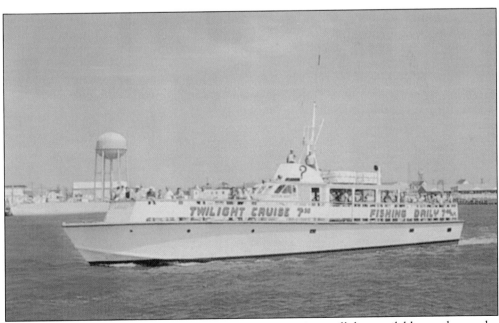

QUESTION MARK. Twilight cruises on a summer evening will be available to those who do not want to fish and are perfect for those who fear sunburns. (Courtesy of the late Fred W. Brueckmann.)

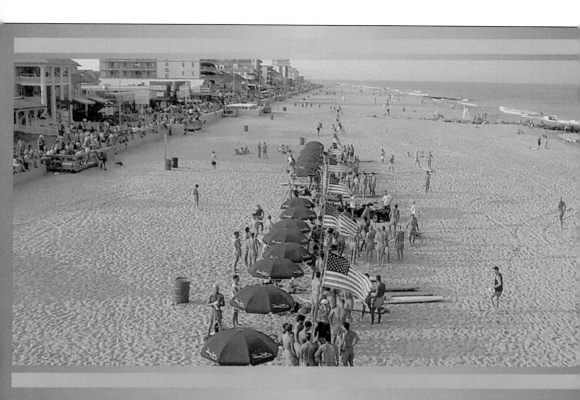

OCEAN CITY LIFEGUARDS

OCEAN CITY LIFEGUARDS. Never forget the lifeguards, whose watchful eyes and swimming prowess have created a lifesaving record that is the envy of resorts up and down the coast. This competition among lifeguards is an annual event. Lifeguards have been a municipal function since the Coast Guard gave it up *c.* 1915. (Courtesy of Roland Bynaker of Trade Winds.)

Ten

THE WAY NORTH

Although Ocean City started out with only a few plots of land, it has grown steadily over the near 125 years to spread all the way up to Delaware. The town's popularity demanded the expansion of a resort that offered limited acreage. The answer was to annex more land, and the town fathers looked toward Delaware for the much needed space. In 1961, Bobby Baker bought two blocks of oceanfront land at 118th Street and Ocean Highway, which was far up the beach then and away from the rest of the resort. It was the first time anyone had extended the seaside retreat that far north.

Over time, annexations allowed the resort to impose itself north until the late 1960s, when Ocean City halted any further land acquisitions and instead adjusted to what it had. However, as the city began moving north, its profile began changing. Instead of a boardwalk lined with shops and booths, only sand existed with a beachline that faced disintegration and high-rise buildings that offered hotel rooms or condominiums.

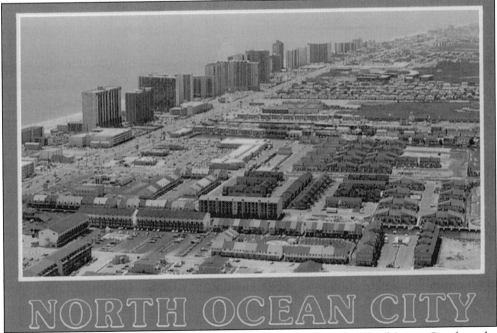

NORTH OCEAN CITY. Photographer Pulling took this aerial shot c. 1980 of Ocean City from the north end and bayside looking south. The bay area is saturated with low-level hotels, condos, cottages, motels, and parking lots. Coastal Highway (far left) separates the bayside structures from the oceanside. The high rises on the left face the ocean. (Courtesy of Pulling/HPS.)

ROUTE 90 EXPRESSWAY. By the sign, one can see that Route 90 serves as a major thoroughfare for entering and exiting Ocean City around Sixty-second Street and runs east and west from Route 50. Other than the Hary W. Kelly Memorial Bridge and Coastal Highway leading into Delaware, Route 90 offers the only other egress out of the resort. A two-lane highway spreading about 10 miles from Route 50 to Ocean City, Route 90 has come under criticism since its construction because of impatient drivers trying to pass on the two-lane road. The route is symbolic in that it signifies the beginning of the northern end of Ocean City.

WELCOME TO DELAWARE. Although a sign officially marks the line between Maryland and Delaware, the two states share a communal goal to bring the best to all tourists who visit the resorts in both states. In fact, other than the welcoming sign, there is no other indication that one has left Maryland and driven into Delaware, and vice versa.

THE GOLD COAST MALL. For many, this mall is a landmark for what has become to be known as "The Gold Coast." The first truly enclosed shopping center, the mall still stands in testimony of the growth of North Ocean City. Owned by Quantum Management of Hyattsville, it's in walking distance of Condo Row and features 4 theaters and 35 stores, restaurants, and services. Uniquely attached is a 202-room Comfort Inn with numerous conveniences. Costing $6 million to build, the Gold Coast Mall was the first indoor shopping center in the resort.

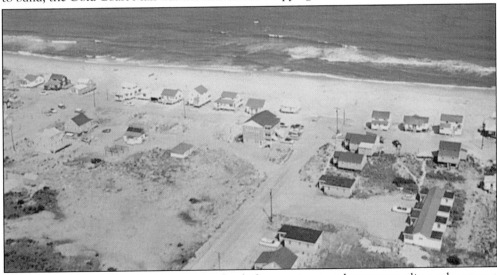

PEPPERS. Located in Fenwick Island, Maryland, these cottages and apartments lie on the utmost northern tip of Ocean City, four blocks south of the Maryland-Delaware line. The location, allowing visitors to have one foot in Delaware and the other firmly planted on Maryland soil, provides surf fishing and boating on the ocean and crabbing and clamming in the bay. Based on the sparseness of buildings and other developments, this photo appears to have been taken in the 1960s. (Courtesy of the late Fred Brueckmann; Tingle.)

Public Safety Building. Constructed in 1994, this modern structure almost seems out of place amid the high rises leading north. The building houses many agencies, such as the departments of police, fire, communication dispatchers, and emergency medical services. Additionally, the state attorney's office is here, as are juvenile services and the district court, which are attached to the building. The structure's placement in North Ocean City also reflects how rapidly the lower resort area is running out of space and how expensive property there is to build on. (Courtesy of Bo Bennett.)

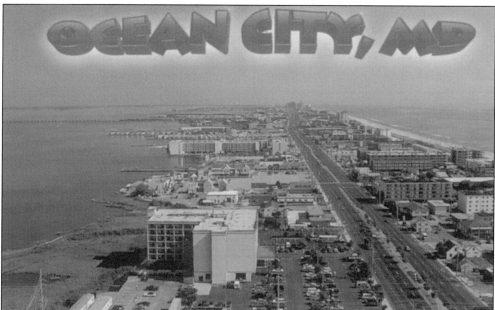

Coastal Highway. This is a mid-1970s picture of Coastal Highway, Ocean City's main street, running north. It's such a busy highway that police are constantly on the lookout for jaywalkers who attempt to cross all eight lanes. The Atlantic Ocean is on the right; Assawoman Bay is on the left. Remaining on Coastal Highway driving north, you'll cross the Maryland-Delaware line and find groups of other ocean resorts (though none as well developed as Ocean City) that include Fenwick, Dewey, Rehobeth, Bethany, and so on, right into New Jersey and New England. (Courtesy of Roland Bynaker of Trade Winds.)

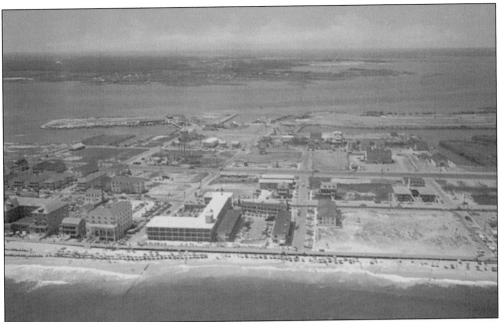

GREETINGS, 1960s. This strip of land shows the new construction of high rises en route to North Ocean City. The southern end of town (on the left) boasts mainly cottages, boardinghouses, low-level hotels, motels, and rentals, but the northern end showcases block after block of high rises that rapidly came into existence in the early 1970s. The bay is in the background, and the ocean is in the foreground. (Courtesy of Tingle.)

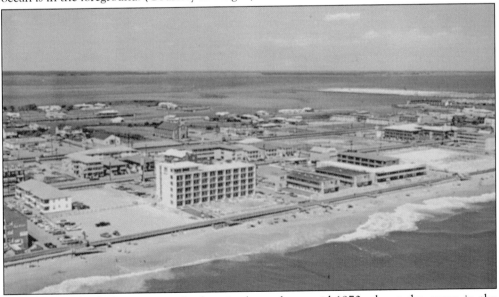

GREETINGS. This helicopter aerial taken in the early to mid-1970s shows the ocean in the foreground and Sinepuxent Bay in the background. On Eighteenth Street is the Sandy Hill Motel (right). At the left on Seventeenth Street are the Ocean Park Motel and the Quality Motel (now called Quality Inn Boardwalk). Compare this photo to the one at the top of the page, using the white two-story building to the left (on the right in the top photo) as the focal point. (Courtesy of the late Fred Brueckmann; Tingle.)

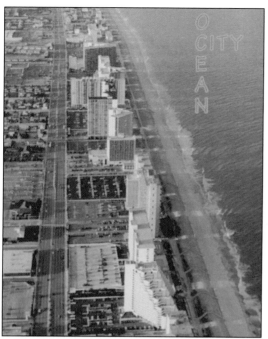

LOOKING NORTH. This picture, taken in the winter of 1992, shows North Ocean City from Ninety-fourth Street at dusk. This is "Condo Row," where the rear of tall buildings abut the beach and their fronts face Coastal Highway. Some of the more unusual architectural structures are readily recognized, such as the first building at the bottom of the photo which is 9400, followed by the Pyramid with its step-down levels. Bayside is at the left of Coastal Highway. (Courtesy of Pulling/HPS.)

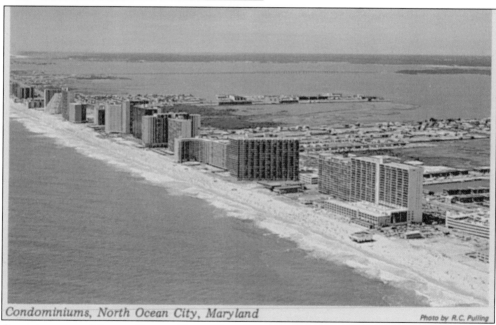

Condominiums, North Ocean City, Maryland

Photo by R.C. Pulling

CONDOMINIUMS, NORTH OCEAN CITY. This photo, looking from north to south, was taken around 1979. It features a classic image of Ocean City high rises fronting the sea, with the bay on the other side. Notice how each building is constructed to take advantage of a view of the ocean, which makes these units more valuable and expensive. The shapes of some of these buildings are not only unique but have won architectural awards. Also note the dredged lagoons with docks on the bayside where cottage-style or low-level lodgings are able to take advantage of the water for boating pleasure. Although bay property can be costly, it remains a little less expensive than oceanfront housing. (Courtesy of Pulling/HPS.)

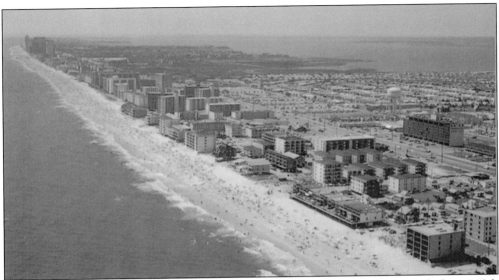

NORTH OCEAN CITY. This 1980 photo shows North Ocean City looking south from 140th Street with the ocean on the left. High rises have been built up on the beach side to give condo and hotel dwellers oceanfront views. Today, these condo units sell for hundreds of thousands of dollars, and the cost for vacationing at the beach in one of the hotels brings a hefty bill during peak season. Hotel rooms run hundreds of dollars per night and yet may go for as little as $50 during off season. Ongoing growth in the resort has required that some buildings be torn down, only to be replaced by bigger, taller, and more extravagant new ones. Many of the old cottages at the south end of the resort have been refurbished or replaced; several of those still standing don't come up to code and thus have to be modified or supplanted by newer structures. (Courtesy of Pulling/HPS.)

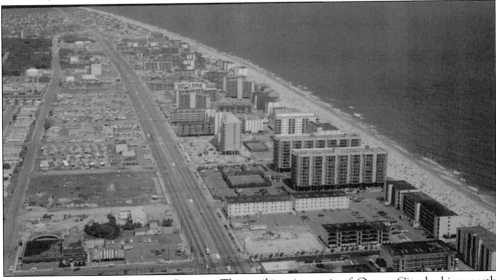

LOOKING NORTH FROM 128TH STREET. This striking image is of Ocean City looking north from 128th Street around Montego Bay. In the picture, the beach appears as a thin, tan strip contrasted against the tall high rises. Coastal Highway runs down the middle of the photo. By the number of high rises and the density of buildings on both sides of the highway, it's likely this image was taken in the early 1980s. (Courtesy of Pulling/HPS.)

BEACH REPLENISHMENT. In 1993, Ocean City (the second-largest city in the state in the summer) produced over $83 million in revenue. It's vital that the resort and the state keep this town healthy, with a special emphasis on the beach area. Through time, the ocean had eroded the beach until it was just a thin strip and unbecoming to vacationers. After much research, the resort agreed to begin a beach replenishment project. The year 1988 saw the start of phase I, while phase II was begun in 1990. The project replaced eroded beach areas by pumping the ocean's bottom near the shoreline and spraying the sand back onto shore. Additionally, 6-foot dunes were erected from Twenty-seventh to 146th Streets. The dunes act as barriers and are held in place by fences, dune grass, and plantings. From Fourth to Twenty-seventh Streets, steel bulkheads at oceanfront encased in concrete rise 3 feet above the boardwalk. Forty-eight ramps and stairs with gates have been erected to allow access to the beach from the boardwalk. The above 1998 images depict a man-made dune with a protective fence around it.

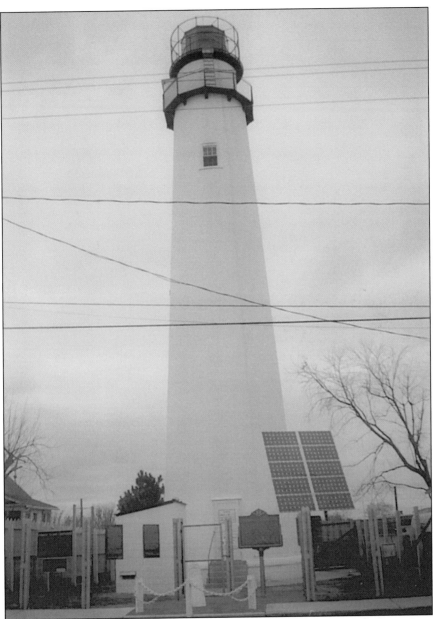

FENWICK LIGHTHOUSE. Built in 1858 at the cost of $23,748.96, the lighthouse stands on what once was Assateague Island, though now this barrier island is named for the land below the inlet made by the storm of 1933. At one time, the east coast barrier islands had greatly extended out to sea from the mainland, making the beach very wide, and they had been connected to form the coastal plain of the mainland and the submerged continental shelf. Over time, erosion has narrowed the beach, and storms have cut through the continuous land slope to break up the long chain of land. The lighthouse now marks the northern boundary between the barrier islands of Maryland and Delaware. Because of the island's elusive shoreline, a lighthouse was needed to help sailors avoid shipwrecks when sailing from Delaware's Indian River outlet to Tom's Cove in Virginia. The structure is 89 feet high (83 feet above sea level) and its light rays carry 19 miles out to sea. Its magnifying lens was imported from France.

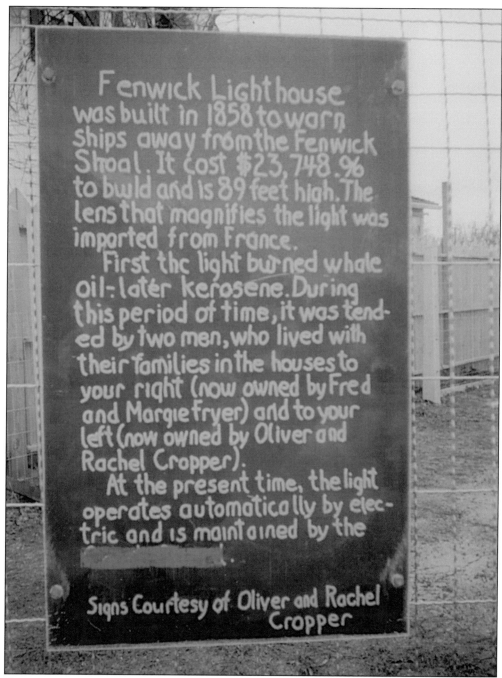

Fenwick Lighthouse was built in 1858 to warn ships away from the Fenwick Shoal. It cost $23,748.96 to build and is 89 feet high. The lens that magnifies the light was imported from France.

First the light burned whale oil - later kerosene. During this period of time, it was tended by two men, who lived with their families in the houses to your right (now owned by Fred and Margie Fryer) and to your left (now owned by Oliver and Rachel Cropper).

At the present time, the light operates automatically by electric and is maintained by the

Signs Courtesy of Oliver and Rachel Cropper

THE LIGHTHOUSE MARKER. This old marker indicates the line between Delaware and Maryland and serves as placement for the lighthouse, which is no longer in operation after nearly 120 years of service. The Coast Guard deactivated it in December 1978. The marker narrates a short history of the lighthouse, explaining that at "First the light burned whale oil [later kerosene]. During this period . . . it was tended by two men. . . . At the present time, the light operates automatically by electric. . . ." The sign is somewhat dated since the lighthouse hasn't been functional for nearly 22 years.

Eleven

WEST OCEAN CITY

With the erection of the new four-lane bridge across the Sinepuxent Bay, plenty of vacant land on both sides of the new highway became available for development. The West Ocean City location chosen between Ocean City and Berlin for the construction of Ocean Downs, a horse racing track, was like manna from heaven for residents. When the new golf courses, Frontier Town, and the new municipal airport were added and soon followed by the addition of a state park and a bridge to Assateague Island, West Ocean City exploded and has already outgrown its shirt, pants, and shoes.

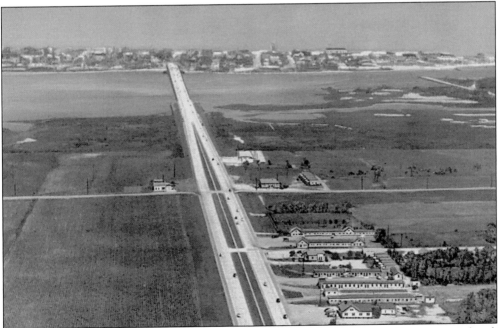

DUAL HIGHWAY AND BRIDGE. When the new bridge across the Sinepuxent Bay was completed, the approaches to Ocean City were empty. Only the Alamo, the Pines, and the Sea Isle motels were built. The rest was grass. This photograph was taken about 1947. (Courtesy of the Harry P. Cann & Bros. Co.)

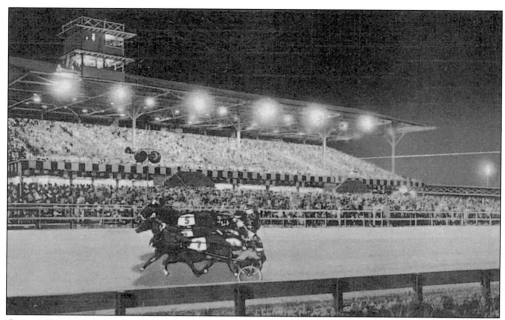

OCEAN DOWNS. Harness racing had been a favorite type of horse racing on the Eastern Shore for a long time, and all of the country fairs, as well as the Delaware State Fair at Harrington, featured it. So, in 1948, a group of local Ocean City entrepreneurs formed a company and built a track, grandstands, and barns. The group obtained racing dates from the State Racing Commission in July and August and opened their complex with a bang. Unfortunately, the crowds and the pari-mutuel betting never achieved a high enough level to pay purses equal to those of surrounding tracks, and, while enabling Ocean Downs to remain open, the profit made was never up to the owners' expectations. The track is now run by Bally at Ocean Downs, but they must compete with slot machines as an additional attraction at Dover Downs. This picture shows a close race among three horses at the track before a full crowd in the stands and along the rails.

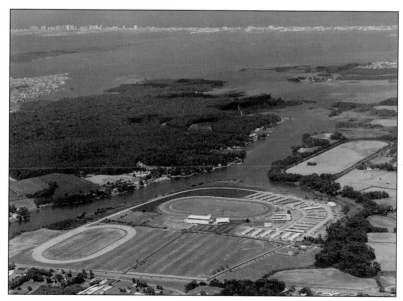

OCEAN DOWNS RACEWAY. This picture shows the tracks under the ownership of Bally's at Ocean Downs. There are more than 20 stables, a new clubhouse, a practice track, and a large parking area. (Courtesy of Bally's at Ocean Downs.)

The Gold Rush - Anniversary Race

THE 50TH ANNIVERSARY RACE. The $10,000, 50th anniversary race on July 25, 1998, was won by Lombardo Laredo A, owned and trained by Daryl Glazer and booted to victory by George Dennis. (Courtesy of Bally's at Ocean Downs.)

FRONTIER TOWN AND RED BIRD. Frontier Town was begun in 1947 on the theory that the frontier had enough attraction to make money. The theory worked. Here, Red Bird, a Cherokee Indian, does the war dance of his ancestors in the Native-American village at Frontier Town. (Courtesy of Frontier Town and the late Fred W. Brueckmann.)

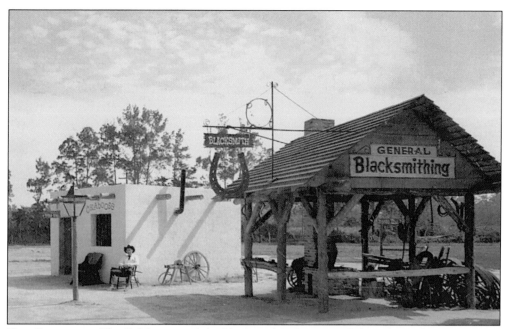

THE CALABOOSE. The Calaboose and the blacksmith's shop are side by side. In this picture, the marshal is maintaining his vigilance over his prisoners. (Courtesy of Frontier Town.)

PRIVATE BEACH. Frontier Town has its own beach on Sinepuxent Bay for the pleasure of those using the facilities. The owners now lease out the frontier entertainment but retain the motel and bathing area. (Courtesy of Frontier Town.)

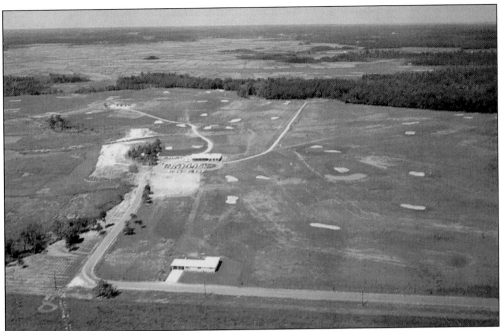

THE OCEAN CITY GOLF AND YACHT CLUB. The club began about 30 years ago with an 18-hole golf course, a small clubhouse, and an idea (to sell lots to the new members). This is how the original course looked, with the ground superintendent's house visible in the foreground. Roy Coffee was the golf professional at that time. (Courtesy of Frontier Town.)

THE CLUBHOUSE. This is how the original clubhouse looked 30 years ago. Today, the dining room is as big as the whole building was then, and, as one employee said, "We had a tiny kitchen."

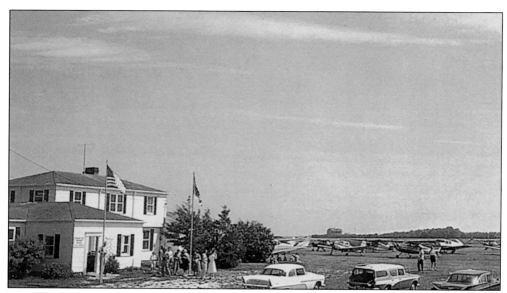

THE OCEAN CITY AIRPORT. This picture is from 1960, when the new airport was opened. At that time, it had only one 3,500-foot turf runway with lights, and now there are four paved runways on 75 acres, new lights, and a new airport building.

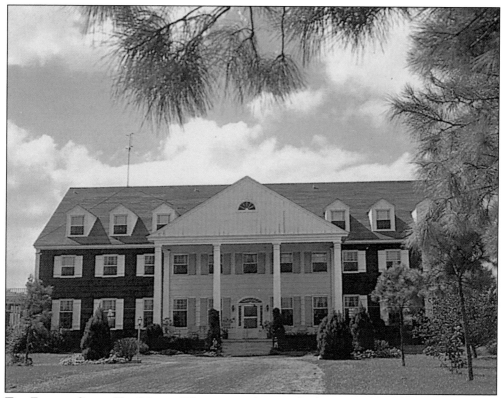

THE FRANCIS SCOTT KEY MOTEL. This picture shows only the original building and the motel extension of the Francis Scott Key Motel, located on the south side of U.S. 50. Since this c. 1955 picture was taken more parking places have been added in front of the building.

Twelve

THE STORM OF 1962

Several storms, particularly hurricanes and nor'easters, made their presence known on the barrier island, as did shipwrecks, such as the one on December 30, 1958, when the African Queen hit a land swelling deceitfully covered by nearly 30 feet of water and was snapped in two. The ship's 200,000 barrels of crude oil choked the ocean. In 1962, a major storm hit the shore and was followed by several others over the last 30 years. The year 1978, alone, witnessed 28 storms.

The storm of 1933 remained the most powerful hurricane to hit the area until the arrival of the March 1962 chaos, which took everyone by surprise. Most of the 1,500 residents assumed the weather event was little more than a thunderstorm; they went about their regular business, thinking nothing of it. But when the storm continued raging on the third day, creating waves 9.5 feet over normal crests, everyone understood this was more than one mighty nor'easter! Mary Corddry states that when the storm had at last passed, 50 business establishments and 15 homes had been totally destroyed; another 105 businesses and 250 homes had been damaged. Some buildings were entirely flattened, while others couldn't be located by their owners because they had been swept out to sea. Forty-first Street and above was hit the hardest, with a temporary inlet created at Seventy-first Street, but Ocean City residents united to clean up the mess and return their hometown to normal.

This chapter takes a look at the 1962 March rampage and how it affected the resort. Unless otherwise stated, all the photographs are taken from the collection of the late Fred W. Brueckmann.

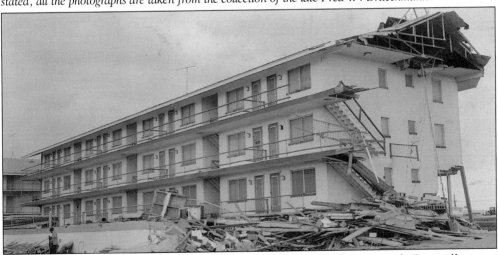

HARRINGTON ARMS APARTMENT. The apartment building on Twenty-ninth Street illustrates the depth of destruction by the storm of 1962. Part of the roof has been blown off, the stairs have collapsed, and the supporting pillars on the opposite side of the building tilt precariously in the sand. Notice the debris piled up outside the building. The storm had left its mark inside the building as well.

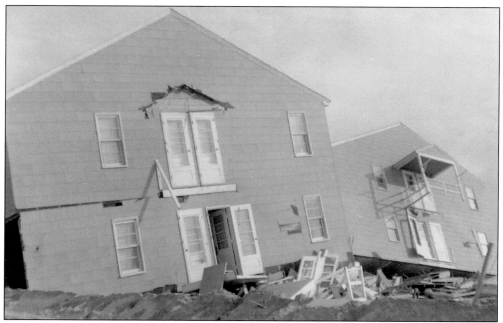

OCEAN BEACH APARTMENTS. This picture was taken of the rear of the apartments to show how the 1962 storm lifted the buildings right off their foundations. The ground reflects the degree of catastrophe by the objects buried in sand and mud. A closer look shows doors and windows that have been ripped off, railings that have collapsed, and other structural parts that have been blown off. Notice to the right of the picture how deeply buried in the muck the street lamp is.

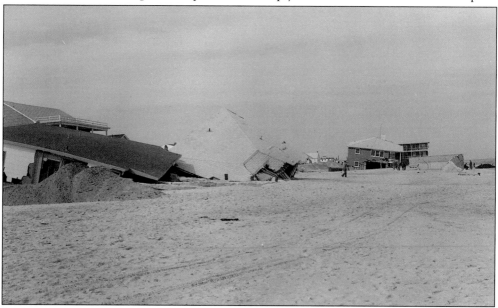

RANDOMNESS. It almost seems as though the March storm took what it wanted and left standing what it didn't. A building in the foreground has totally collapsed to its roof, while behind it stands another structure looking touched but not entirely damaged. The second structure in the photo seems to tip on its nose, while the third and fourth buildings have been affected by the washing away of sand but remain intact.

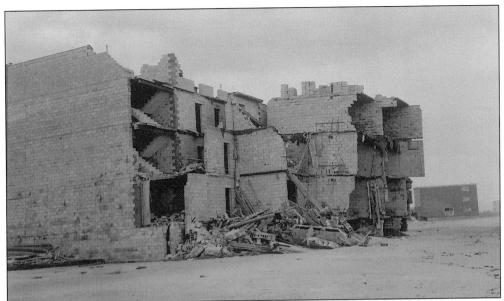

NEW FLAGSHIP. Located on Thirty-third through Thirty-fifth Streets, this once-solid building of cooperative apartments embodies the extensive damage done by the storm. Much of the debris piled in front of the structure tells the story itself. To the right of the New Flagship, in the background, stands the Star Dust Motel, unharmed.

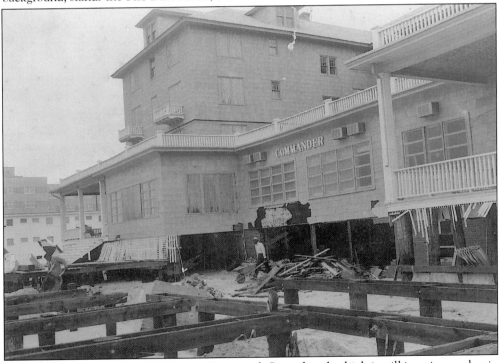

THE COMMANDER HOTEL. This famous Fourteenth Street hotel, which is still in existence but in a more modern form today, took a grand hit from the 1962 storm. Not only was the boardwalk in the foreground demolished, but the building itself was crushed, as seen in the splintered and fragmented siding, lacerated walls, and eroded interior structures.

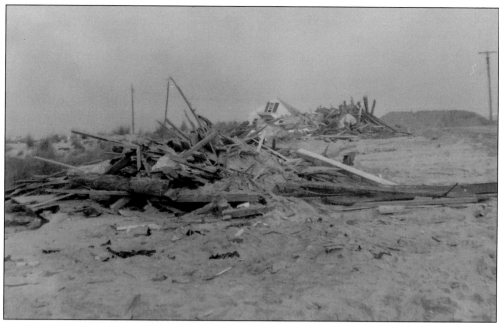

A "Flattening." Standing at a distance from the focus of the picture, one can see the massive destruction where winds, rain, and ocean have flattened any buildings on the shore in the area. The tilted roof line of one building in the background is visible.

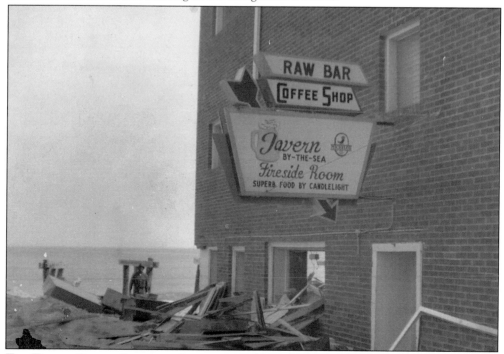

The Tavern By-the-Sea. A worker stands in the far background surveying the mess amassed by the storm. So much muck has washed ashore from the sea in the background that it has piled up beyond the first floor windows of the tavern. It's a wonder the sign is still hanging. This restaurant is part of the Sea Scape Motel.

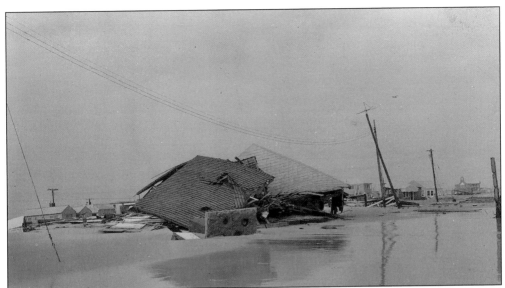

FLOODING AT EIGHTY-FIRST STREET. The buildings in the foreground have totally collapsed from the high tides, flooding waters, and powerful winds. Water has surged way up on shore, weakening structures on the shoreline. Look at how the storm also affected telephone poles and yet did very little damage to the buildings in the background.

AN ALLEYWAY. Imagine having to clean this mess, after sand and water had filled the bottom rooms of the building on the right side and covered the sides of the building on the left.

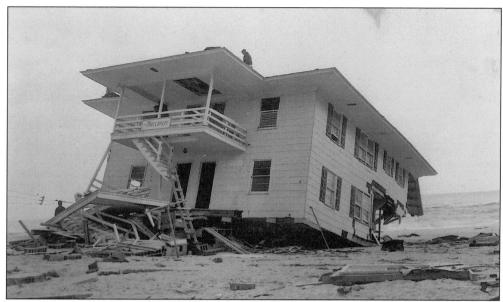

BUCCANEER APARTMENTS. Between Twentieth and Twenty-first Streets perilously stands the remains of this building. The entire rear of the building, much of which has been ripped off, is nearly in the ocean. The structure has been lifted off its foundation and sits lop-sided on the sand. Stairs have collapsed, windows have broken, and part of the building has been wrenched from its base. Notice the figure working on the top of the roof in an attempt to repair it.

INTERIOR DAMAGE. Imagine having to clean out this dwelling where sand and mud cover the floors as though they were a type of specially designed carpeting. Even the stairway risers show some of the soiling. Though the muck swept through the doors of the building, its force did no damage to the other room, where pots and pans and dishes weren't even touched. No doubt paneling as well as floors had to be replaced.

124

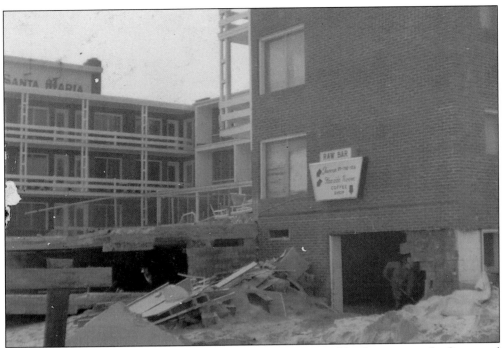

THE SEA SCAPE. This photo shows the incredible erosion caused by the storm to the first motel in Ocean City. Notice how the structure has been eroded from underneath, destroying the coffee shop and Sea Side Room. Mounds of sand brought in from the storm cover everything, and whatever was in the path of the high winds and tides has collapsed. This motel was built by the Harmon family in the 1950s in three phases. It was bought at auction in 1978 by four sisters and their husbands and gained fame for Shirley's (Thomas) Zesty Piano Bar, as well as its eating facilities, which offered "wining and dining by candlelight." Diners who wanted elegance could eat in the Neptune Room. The food and service was so well thought of that the restaurant was awarded the "Duncan Hines Recommendation." (Courtesy of Alladin Color, Inc., Florence, New Jersey.)

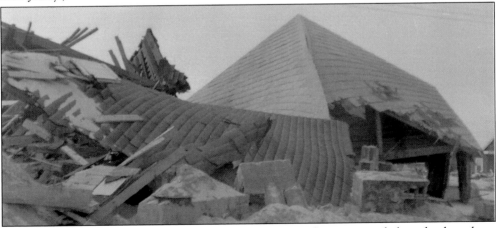

A COLLAPSED BUILDING. The storm did so much damage to this structure, believed to have been a lodging facility, that it no longer is recognizable. Even the building's concrete base has been destroyed. Ironically, the very small structure partly visible to the far right remained intact. Notice the downed phone pole.

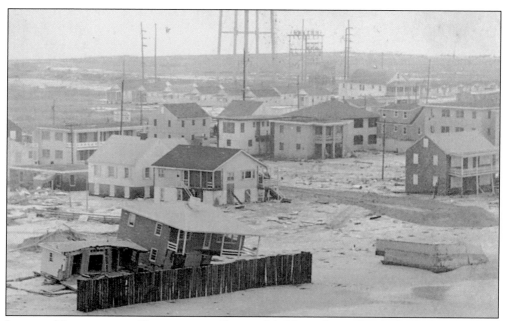

LOOKING NORTH TOWARD FORTY-FOURTH STREET. Mud lines the road and piles high everywhere as though it were a deep layering of snow. While many buildings faced the storm unfazed by winds, waters, and rains, others that were within arm's reach were nearly toppled and completely ravaged. Consider the irony of the destroyed buildings in the foreground to those left unaltered in the direct background. (Courtesy of Tingle.)

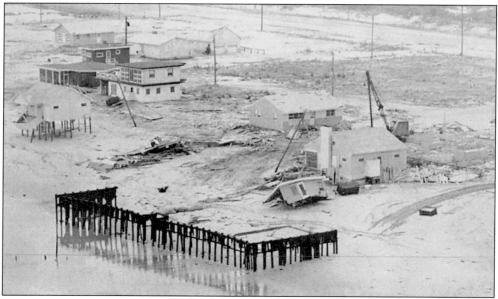

LOOKING SOUTH FROM NINETIETH STREET. This photo impresses viewers with the strength of the storm. Utility poles lean and threaten danger; buildings are crunched like models. Pile drivers attempt to plant poles to support the remainders of the structures. Other structures within reaching distance of the ones in the foreground show no devastation at all. Look at the waterline lapping right up against the fence. The bay is in the background. (Courtesy of Tingle.)

Bibliography

Accommodations Guide. Ocean City, MD: 1999.

Arts Atlantica: The Boardwalk Exposition. Ocean City, MD: June 4, 1999.

Baja's; Family Amusement; Grand Prix. West Ocean City, MD: 1999.

City Meeting Minutes. October 28, 1958–December 8, 1960.

"Church of the Holy Spirit." Ocean City, MD: Church of the Holy Spirit.

Corddry, Mary. *City on the Sand*. MD: Tidewater Publishers, 1991.

The Daily Times. Salisbury, MD: 1998–99.

Dessodd, Alan L. "Gloria Storm Is Only . . . in a Hurry." *Washington Post*, "The Metropolis," 1965.

The Dispatch. Ocean City, MD: January 1999.

Dolle's Candyland. Ocean City, MD.

Ferguson, Anita. "Ocean City Mulls Parking Lot." *Maryland Times Press*.

Fisher, Tim. "A Bang-Up Fourth Holiday." *Ocean City Today*, June 7, 1998.

Frontier Town: Campground and Western Theme Park. Ocean City, MD: 1999.

Hale, Charlotte. "Light Show; More than 300,000 Took in Westerfest, Final Tally Shows." *The Beachcomber*, February 11, 1994.

Harrison, Sandra. "A History of Ocean City, Maryland" by Mary Ellen Mumford. . . . Mayor & Council of Ocean City, MD; Calvin B. Taylor Banking Co, Berlin, MD.

Hilson, Robert Jr. "Six Bad Storms in State Since '36." *Evening Sun*, September 26, 1985.

Hurley, Suzanne and George Hurley. *Ocean City, A Pictorial History*. Virginia Beach: Donning Co. Publishers, 1979.

Kanamine, Linda. "Gloria's Aftermath; City Will Seek No Federal Aid for Clean Up." *Ocean City Times*, 1985.

———. "No Boardless Walk for Ocean City." October 26, 1985.

Lynch, Heather. "Winds, Rain Makes Soggy Springfest." *Times-Press*, May 1998.

Ocean City, 1998 Special Events. Ocean City, MD: Ocean City Recreation & Parks, 1998.

Ocean City Life Saving Station. Ocean City, MD: 1999.

Ocean City, Maryland. Spring 1999.

"Ocean City Revisited 1998." Baltimore: Lipman, Frizzell & Mitchell LLC.

Ocean City Today. Ocean City, MD: 1999.

Princess Royale. Ocean City, MD: 1999.

"Sunfest '98 Marks 24th Summer Season Finale." *Ocean City Today*, September 18, 1998.

Sunny Day Guides. Ocean City, MD.

Suznavick, David. "State May Soon Care for OC Inlet." *Times-Press*, May 10, 1995.

"Town of Ocean City: Ocean City, Maryland: A Report for All Seasons." September 28, 1998.

Visitor Guides. 1998, 1999.

"A Walking Tour of Historic Downtown Ocean City." Worcester County, MD: Arts Atlantica, 1995.

Year 2000, Sea for Yourself. Ocean City, MD: Town of Ocean City, Department of Tourism, Ocean City Convention & Visitors Bureau, Ocean City Public Relations Division.

Interviews were conducted with the following individuals:

Abbott, Donna, of the Ocean City Public Relations Office;
Bennett, R., for information on the Sea Scape;
Caine, Jamie, for information on the development of North Ocean City by James Caine;
Dobrowlski, Norma, of the Ocean City Public Relations Office;
Hanna, Frank, the owner of Marina Deck Restaurant and Harpoon Hannas;
Heiderman, Tom, the owner of the Hobbit;
Houck, Phil and Maria, for information on Bull on the Beach;
Moore, Patricia, the operator of Baja, Grand Prix;
Phillips, Jeff and Cathy, for information on the Eastern Surfing Association;
Sacca, Nancy, for information on the development of the south end of the resort;
Simpson, Mac, for information on the Pyramid high rise;
Smith, Charlie, for information on Fager's Island Restaurant & Lighthouse Club Motel;
Taylor, Lauren Connor, for information on the Santa Maria and other early lodgings;
Thomas, Mr. and Mrs. Richard Jr., for information on the Capri;
Von Rigler, Gregory, for information on Sky Tours;
White, Aaron, for information on the Fountainhead;
Wilkerson, Tim, for information on Captain Bob's;
Woyt, John, for information on Nite Lite.